EXPLORING Contemporary Craft

HISTORY,

THEORY &

CRITICAL WRITING

Co-published by Coach House Books with
The Craft Studio at Harbourfront Centre

© Coach House Books and Harbourfront Centre, 2002

Published with financial assistance from the Canada Council
for the Arts and the Ontario Arts Council

The Canada Council | Le Conseil des Arts
for the Arts | du Canada

ONTARIO ARTS COUNCIL
CONSEIL DES ARTS DE L'ONTARIO

National Library of Canada Cataloguing in Publication

Main entry under title:
Exploring contemporary craft: history, theory and critical writing
/edited by Jean Johnson, C.M..

Thirteen essays and articles originally presented at a symposium held in March 1999.
Co-published by Harbourfront Centre.
Includes index.
ISBN 1-55245-107-0

1. Handicraft–Canada–Congresses. I. Johnson, C.M., Jean
I. Harbourfront Centre. Craft Studio
NK841.E97 2002 745.5'0971 C2002–902381–5

Printed in Canada

Cover artworks, clockwise from far left are by Karli Sears, Alex Hiu Man Yeung,
(brooch) Vivienne Jones, Chung-Im Kim

ABSTRACT

This collection of papers and texts presented at the "Exploring Contemporary Craft: History, Theory & Critical Writing" symposium held in March 1999 in Toronto reveals the diversity of thinking and practice in contemporary craft in Canada. The goals of the symposium were:

To explore the history of contemporary craft from a national and international perspective and to look at how that history is being researched and disseminated.

"There is a distinct crafts culture in North America. After World War II, it grew from workshops where craftsmen and craftswomen taught each other techniques, from craft fairs where a new marketplace was developed, and from art schools and universities. This culture was conditioned more by face-to-face contact than by writing and reading, and evolved in small communities that, at first, weathered glacial indifference from the public. One could imagine the craft world as a circle of covered wagons in some late-night Western movie, banded together for co-operation and common protection." – **Bruce Metcalf**

To discover craft theory's effectiveness and influence on current education and craft practice.

"The separation of craft from art and design is one of the phenomena of late-twentieth-century Western culture. The consequences of this split have been quite startling. It has led to the separation of 'having ideas' from 'making objects.' It has also led to the idea that there exists some sort of mental attribute known as 'creativity' that precedes or can be divorced from knowledge of how to make things. This had led to art without craft. At the same time there has been the evolution of 'the crafts' as a separate art form. Enough people have wanted to go on making things. Enough people believe that they can expand their ideas and knowledge about the work through learning and practicing a craft."– **Paul Greenhalgh**

To review current critical writing practice and to formulate a strategy for expanding the base of critical writing on craft.

"Craft criticism is a mess. It has a shaky past, uncertain credentials, no theoretical basis, and only a vague idea of an ideal. A lot of it is defensive, operating on the assumption that crafts is an underdog field, unfairly denied status as art. Yet almost never does this defensive criticism really consider whether being defined as art is a good thing. In addition, crafts criticism is the focus of endless lamentations – that there are no opportunities to publish criticism, that there is no suitable language of criticism, that there are no capable critics... Perhaps writing about functional work should never be restricted to the work alone; perhaps the whole way that a maker lives and deals with material goods should always be part of the discussion. Perhaps the object is just the physicalization of a philosophy that shapes a lifestyle." – **Janet Koplos**

ACKNOWLEDGEMENTS

The Craft Studio at Harbourfront Centre acknowledges the generous financial support for the symposium and this publication from:

Canada Council for the Arts

Jean A. Chalmers Fund for the Crafts

Ontario Arts Council

Toronto Arts Council

Sheila Hugh Mackay Foundation Inc.

The Samuel and Saidye Bronfman Family Foundation

Ontario College of Art and Design

Ontario Crafts Council

We also extend our thanks to the following organizations and people for their support and contribution to this project:

British Council

Bounty, the craft shop at Harbourfront Centre

Gardiner Museum of Ceramic Art

Nova Scotia College of Art and Design

Prime Gallery

Textile Museum of Canada

Sheridan College School of Crafts and Design

R. Melanie Egan

Dr. Brian Sparkes

Enid Rae Maclachlan

Athena Tsavliris

Lauren Helmkay

Nikki Sidiropoulos

Much of the success of this program is due to the support of our incredible colleagues at Harbourfront Centre, including the promotional material designed by our graphics department, and the efforts of our marketing, publicity and box office staff, the event production crew, our technicians and the folks in administration.

CONTENTS

Editor's Note: Glenn Allison was a participant in the symposium, but, unfortunately, his paper was not available.

The Steering Committee

Beth Alber, metalsmith, head of jewellery and metals, Ontario College of Art and Design

Sandra Alfoldy, professor of craft and design, Nova Scotia College of Art and Design

R. Melanie Egan, coordinator, the Craft Studio at Harbourfront Centre

Steve Heinemann, ceramist

Jean Johnson, C.M. (Chair), craft projects manager, Harbourfront Centre

Betty Ann Jordan, freelance writer specializing in art and craft

Susan Warner Keene, fibre artist and faculty, textile studio, Sheridan College School of Crafts and Design

Barbara Klunder, artist and designer

Burton Kramer, graphic designer, Kramer Design Associates

Lynne Milgram, Ph.D, anthropologist researching women's production in the Philippines

Rosalyn Morrison, executive director, the Ontario Crafts Council

Skye Morrison, Ph.D, faculty, Sheridan College School of Crafts and Design, researching textile work in India

Sarah Quinton, contemporary curator and exhibitions manager, Textile Museum of Canada

Ron Shuebrook, artist, president, Ontario College of Art and Design

Heartfelt thanks to each and every member of the steering committee for their integral contributions. Without the committee's valuable expertise and support, this seminal conference could not have been created.

Particular thanks to Burton Kramer and Betty Ann Jordan for their invaluable professional contribution. Additional thanks to Alana Wilcox and the crew at Coach House Books.

– Jean Johnson, C.M., Editor/Craft projects manager, Harbourfront Centre

PREFACE

In recent years the craft community has recognized the lack of formal academic discussion on contemporary craft practice. In the design schools, the history of design is taught with little attention to the overall picture of the development of the craft movement in Canada or elsewhere. A comprehensive look at the theory of craft education has been missing and the lack of critics to discuss the work created by craftspeople obviously contributes to the absence of mention in the media. While there are several notable provincial or local publications devoted to a discussion of craftspeople and their work, there is no publication presenting a national picture.

Over the years the Craft Studio, Harbourfront Centre, has touched on craft history, theory and critical writing in its lectures, marketing conferences and other programs. Discussion with Studio advisers, craftspeople and design college faculty indicated a need to address these topics in depth. In response to their concern, a steering committee representing all areas of the craft community was assembled to create a symposium to focus on contemporary craft history, theory and critical writing. For over two years, the committee discussed the issues and identified individuals who could best address these topics. It was decided that the Canadian and international presenters should represent the broadest, most forward thinking possible. (See facing page for a list of the fabulous steering committee members.)

Vital to the organization of the event was the addition to the working committee of three facilitators: **Sandra Alfoldy**, Ph.D (Concordia University) for craft history; **Neil Forrest**, ceramist and professor at the Nova Scotia College of Art and Design, for craft theory; and **Sarah Quinton**, contemporary curator and exhibitions manager, Textile Museum of Canada, for critical writing. Their co-ordination of the speakers was essential and brilliant. Without the financial support of the Jean A. Chalmers Fund for the Crafts, the Canada Council, the Ontario Arts Council and the Toronto Arts Council, the British Council, and the Sheila Hugh McKay Foundation, this event could not have been mounted. Support from Harbourfront Centre staff made it possible.
– Jean Johnson, C.M., craft projects manager, Harbourfront Centre

HARBOURFRONT CENTRE

Established in 1972 to revitalize the waterfront, Harbourfront has become world renowned for its cultural, educational and recreational programs, which are offered, for the most part, for free. One of Canada's largest and most active cultural centres, presenting hundreds of events and activities to the public, Harbourfront Centre attracts more than 3.5 million visitors annually and collaborates with more than 450 community-based organizations to showcase activities.

Many of the Queens Quay West programming facilities have been carved from industrial buildings left derelict on the waterfront lands. A disused food warehouse is now home to the Premiere Dance Theatre; a trucking garage was transformed into York Quay Centre; and a former refrigeration and heating plant houses the Du Maurier Theatre Centre and the Power Plant Contemporary Art Gallery. The hub of programming activities, however, is York Quay Centre, which houses the Craft Studio and Bounty, our retail craft shop. The Studio Theatre seats two hundred while the Brigantine Room, with flexible seating for 300 to 450 people, is where the Harbourfront Reading Series and other programs take place. The Lookout space is home to the School by the Water and Harbourkids Creative Workshops, an active hands-on program for families. Gallery spaces include the York Quay Gallery, York Quay Gallery II, the Photo Passage, Case Studies and Uncommon Objects (dedicated to craft exhibitions). At the south end by the pond/skating rink are the Lakeside Terrace, a performance space, and Lakeside Eats restaurant and café. Harbourfront also offers nautical events including ships visiting from all over the world.

The Craft Studio at Harbourfront Centre

In 1974, The Craft Studio was initiated as a summer program called Sheridan Harbourfront and located on an abandoned industrial site on the waterfront. Students and faculty from Sheridan College School of Crafts and Design set up equipment and invited the public to watch and participate in activities in the areas of glass, jewellery, textiles and ceramics. After a major storm, the studios were given space in York Quay Centre, where they remain to this day.

Operated year-round in full view of the public, the Craft Studio is an important bridge between school and a professional career for craftspeople. It is recognized for its continuing support of contemporary craft and craftspeople through residencies, workshops and master classes, exhibitions, lectures and classes for the craft community and the general public. Resident artists teach beginner classes.

The Studio offers residencies in ceramics, hot glass, textiles and metal, including full use of professionally equipped studios supplemented by lectures and workshops with nationally and internationally renowned

craftspeople and artists. Residencies are renewable up to three years, and three-month summer scholarships are available for students returning to college. Each studio offers a free residency for a year to an incoming graduate. A jury, comprised of the Craft Studio staff, professional advisers (drawn from the craft community) and the current residents, selects the new studio residents. Criteria are talent, skill, originality, commitment to a full-time professional career as a craftsperson and ability to work in a co-operative studio in front of the public. Over 300 craftspeople have completed residencies and many are now working successfully in their own studios.

The Craft Studio collaborates with many Ontario and Canadian craft and art organizations in supporting and promoting the crafts. Programs presented by the Craft Studio include:

Degrees of Collaboration (since 1983): brings craftspeople, architects and designers together to discuss contemporary installations and to give presentations on their work.

International Creators (since 1981): Renowned craft artists give lectures on their work and conduct two- or three-day workshops and master classes.

Visiting Artists: an ongoing program of lectures and workshops by local and other artists who may be visiting at one of the design colleges or in Toronto for an exhibition.

To Market! To Market! (since 1990): an ongoing program of lectures, panel discussions and workshops on all aspects of the marketing of craft work.

Exhibitions: Harbourfront Centre provides exhibition possibilities for resident Craft Studio artists and the craft community in the York Quay Gallery. As well, Uncommon Objects window cases offer regular craft exhibition opportunities, often coinciding with various Harbourfront festivals.

Exploring Contemporary Craft: History, Theory and Critical Writing (March 1999): a symposium on contemporary craft issues focusing on craft education with fifteen invited national and international curators, critics and craftspeople.

Beadazzled (1995, 1997, 1999): conferences on beads, beading and bead-making and embroidery; a look at historical and contemporary work.

Educational Projects: twenty senior high school students create work in each studio during an annual five-day visit and mount an exhibition of their work in the Uncommon Objects windows.

Regular Studio Tours for schools and the public, as well as Outreach programs into the schools; an ongoing program.

Contemporary Craft History

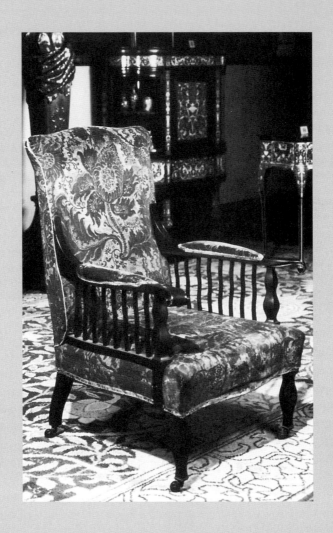

William Morris
Morris Adjustable Chair, c.1865

Bruce Metcalf is a metalsmith/jeweller and writer living in Philadelphia, Pennsylvania. His jewellery has been exhibited widely in the US and internationally, and his writing has appeared in *American Craft, Metalsmith, Studio Potter* and other publications.

Contemporary Craft: A Brief Overview
Bruce Metcalf

My initial mandate from Jean Johnson was to provide a "thorough overview/ background – going way back to include the Renaissance, Industrial Revolution, Arts and Crafts movement, Bauhaus – from Bruce Metcalf's particular point of view." Well, that's a tall order. Given that I teach a semester-long course on the subject, and that even with fourteen weeks I must omit certain parts of the history of contemporary craft, I don't think I can give you much in the way of a thorough overview. Since I'm compelled to condense this subject into a mere forty minutes, I have to paint this picture with a very broad brush. Probably, all that will remain will be my particular point of view. So, my apologies in advance. You're going to get a pretty subjective overview.

The topic here is contemporary craft. We're talking about the making of objects removed from necessity – we don't need handmade objects to survive anymore – and we're talking about a collective response to industrialization. These, to me, are the two basic facts about modern crafts. In other words, craft, as we know it, is a recent invention. It is not an antique. It is not a picturesque holdover from a distant bucolic past. Actually, modern craft went through two reinventions: once in England starting in the 1850s, and a second time in Europe and North America after World War II.

What Is Craft?
Now "craft" is a tricky word, with no precise definition. This is a symposium about craft, but it's doubtful that there are any plumbers or roofers here, confused that this might be a conference about building trades. So we all know roughly what the word means, in the sense of the British Crafts Council or the American Craft Museum.

But we would also all probably argue about precisely what the word means. So I'll say that "craft" is a cultural construction, not some independent fact. And, parallel to Arthur Danto's idea of the artworld, I'll also say that there is a craftworld, and that the institutions of the craftworld effectively get

to decide what the word means. Finally, I would say that the meaning of the word "craft" changes as societies change, and people tailor the word to their specific needs and desires.

Before the Arts and Crafts movement, what we now think of as craft had several related implications. The first was skilled work, in the sense that we now speak of the "craft" of writing or the "craft" of cooking. This sense of craft hearkens back to mystery and magic, as in witchcraft, and suggests that skilled work is a form of secret knowledge.

Craft, from our retrospective view, also meant the decorative arts. Generally, this term denoted handmade luxury goods for use and display inside buildings, and for use and display on the human body. The use of the word "arts" suggests a certain high-toned quality, proposing an opposition between a couch and, for instance, a hand tool. The couch might wind up in an art museum, under the purview of a decorative arts department, but the tool remained anonymous and invisible, not worthy of preservation until the early part of this past century.

Craft also meant trades and folkways. That is to say, there were long traditions of pre-industrial production of handmade objects, from roof thatching and chair bodging to weaving homespun and carving treen. Some of these trades became professionalized, organized into guilds and unions, as with metalsmithing. Over the course of the eighteenth and nineteenth centuries, some of these trades adapted to industrialization, as the trade of metalworking, for example, has evolved into the trade of machining. Other trade skills, like hand-setting type for printing, faded under the onslaught of modern technologies.

Folkways, which tended to take place in and around the home, were eroded by the availability of mass-produced consumer goods. Why weave a coverlet when you could buy one at the local store? But various folk traditions continue in pockets, particularly on the margins of consumer culture. A few of these traditions even survived long enough to become celebrated and exploited, as in Navajo weaving and pottery.

All these senses of the word "craft" survive today. I hear advertisements promoting "handcrafted" beer, reflecting the idea of craft as skilled and careful work. Obviously, the decorative arts are healthy, particularly in well-funded museums and in the antique marketplace. And the trades are doing just fine, as long as they serve the needs of homeowners and industry. And folk crafts survive, particularly in poor countries where mass-production has not fully penetrated the marketplace.

Modern Craft – Theory, Practice and Resistance
But the "craft" that is the subject of this symposium is not fully any one of these categories. It's my contention that the craft under discussion here is a recent invention, a social adaptation in the face of industrialization. In fact, I could reasonably claim that modern craft was invented by William Morris, when he decided in 1856 to furnish his apartment on Red Lion Square. Morris

and his buddies had a collection of pseudo-medieval furniture made up, which they intended to paint with scenes of chivalry and legend.

I would suggest that Morris created a new category of objects. These things were not only luxury interior decor, nor were they only the products of a trade. They are craft in the fully modern sense. They had several important characteristics, which were fleshed out over the next forty years of the Arts and Crafts movement.

First of all, they were theorized. They were both the product and subject of discourse. Like many of his contemporaries, Morris was profoundly influenced by John Ruskin, and particularly by the passages from *The Nature of Gothic* that talked about labour. Ruskin was speaking directly about the differences between carving Gothic architectural ornament and carving Classical ornament, and he stated emphatically that the quality of labour was vastly different. It took no special imagination to see that Ruskin's critique could be applied to factory labour of any kind and that *The Nature of Gothic* addressed the social conditions of Victorian England. So, while the Neo-Gothic style was hardly new, it was new to regard furniture as being aligned with a social critique. With Morris, craft entered a world of theory.

Secondly, while Ruskin was speaking about the dignity of labour, Morris practiced it. Morris carved wood, embroidered, painted furniture, dyed fabrics, wove tapestries, illuminated manuscripts, set type and printed books. Perhaps it's difficult to imagine how shocking this was to his contemporaries, for whom painting was about as far as a gentleman could go into the world of physical labour. But Morris got his hands dirty and he was legendary for getting completely engaged in one type of handwork or another. He spent several years with his hands and arms dyed blue from indigo: he literally carried the stain of hand labour. I think Morris broke an important barrier, for he made it possible for his many followers to engage in work that had previously been reserved for the lower classes. He gave handwork a classlessness that survives to this day.

Not only did Morris pull handwork out of the working classes, but he put women's work on an equal footing with men's. Morris was an early enthusiast of embroidery, and stitched objects became an important staple of the Arts and Crafts movement. While it's true that embroidery was often the preserve of women, it's also true that the many Arts and Crafts exhibition societies would place these embroideries on equal terms with the work of men. In fact, stitchery became an icon of reform: when the Belgian painter Henri Van de Velde started to embrace Arts and Crafts ideals, his first notable work was a fabric appliqué, *Angel Watch*, in 1893.

Van de Velde's defection was not unusual. As the Arts and Crafts movement progressed, and as it became allied with the Aesthetic movement, it was generally held that art – and craft – had equal aesthetic potential. Much of this attitude might be traced to the era's great admiration for imported Chinese and Japanese ceramics. So, it was not unusual to find an aesthete having her portrait painted along with an admirable vase, the whole mise-en-

scène amounting to an argument for parity between pots and paintings. And many painters behaved as if this were true. For instance, Edward Burne-Jones painted on furniture and designed jewellery. Others, like Van de Velde, gave up painting for careers in design. In general, a craft object was assumed to be able to satisfy the same level of expectations brought to a painting or a sculpture. Beauty was not confined to the fine arts. Of course, such open-mindedness was short-lived, and craft has again been demoted to the status of aesthetic also-ran.

To me, the most important contribution of the Arts and Crafts movement was to tie aesthetics to social awareness. As I said, one of the movement's primary inspirations was Ruskin's *Nature of Gothic*, and the crucial passages are his critique of the mechanization of human labour. Ruskin had the vision to critique architecture on the basis of how it was made and how the labourer was forced to work. These passages are a key document of the movement and they remain, in some ways, an urgent critique.

Ruskin's genius was to move attention away from a disinterested contemplation of an artwork and toward a broader examination of the society from which the work emerges. Before the fact, Ruskin challenged the doctrine of Greenbergian modernism and the whole concept of the autonomous art object. It was no accident, then, that Morris became a socialist, or that the Bauhaus was concerned with the well-being of the working class. To my way of thinking, the alignment between craft and social engagement for the next century can be traced back to Ruskin.

In its original form, the Arts and Crafts movement was a reaction against the dominant culture of its time: against mass-production and shoddy goods, against factory labour, against ugliness and against capitalism. In the twentieth century, I think most observers have conceded that the factory system is unavoidable and that a more legitimate complaint is against the exploitation of workers rather than the existence of the system in the first place. Similarly, we have seen that not all mass-produced goods are bad and that machines are capable of making very good, useful and even beautiful things. And some of us have concluded that the socialist dream of state ownership of the means of production can lead to crimes and inefficiencies at least as big as those of the capitalist system. But I think it's important to remember that craft is still an opposition, just as it was more than a century ago:

Craft still stands against the anonymity of mass-production and for the personalized object.

Craft still stands against ugliness and, on occasion, for beauty.

Craft still stands against big-money capitalism and for small-scale entrepreneurship.

Craft stands against corporate labour, where most workers are replaceable parts in a bureaucracy, and for individual self-determination.

Craft stands for the rich potential the human body at work and against disembodiment in all its forms.

Craft continues to be a social movement, often intuitive and without leadership. I see craft as a collective attempt to relocate personal meaning in a largely indifferent world. As a teacher and observer, I constantly see how craft functions as a vehicle to construct meaning and how it gives substance and dignity and grace to individuals' lives. Furthermore, I suggest that any history of contemporary craft would have to account for this fact.

The Second Revival – Craft as Business and Craft as Art

The first reinvention of craft had international repercussions in Germany and Austria, in Scandinavia, and in the U.S. and Canada. It supplied a persuasive argument for the production of a new kind of handmade object – one with an ideological grounding – and energized thousands of people for decades.

In England and the U.S., the Arts and Crafts movement had lost much of its momentum by World War I. It had become strongly identified with a particular visual style, and that style had become passé. In the States, one of its most passionate leaders, Elbert Hubbard, went down on the Lusitania in 1915. Gustav Stickley, the other great American popularizer of Arts and Crafts, overexpanded his business just before the war. His Craftsman Work-shops collapsed, also in 1915. But Arts and Crafts ideals lived on in people like Bernard Leach and Eric Gill, and in institutions like the manual arts education movement in the United States. After the turn of the century, teaching crafts became an important part of higher education, and not just in art schools. For instance, I heard it said that the Wisconsin state university system once required all students to take at least one manual arts course. One of these courses was pewter-working, and to this day Wisconsin continues to be a centre of that particular craft. Arts and Crafts ideals also survived, some-what modified, in the teachings of the Bauhaus. While the later Bauhaus emphasized new materials and new technologies, the Bauhaus program also insisted that every student master a particular material. The theory was that, before one could design effectively, one must thoroughly understand how a material could be worked. And, of course, for many of the workshops, the other goal was industrial production, for which handmade objects might serve as prototypes.

In the Bauhaus workshops, craft was first tied to the concept – and the style – of modernity. The form of modernity was held to be geometric, free of ornamentation and highly abstract. The teapot designs of Marianne Brandt illustrate the Bauhaus style perfectly. But modernity was held to be far more than a style: it was intended as a kind of manifesto. First, the unadorned, geometric-form language was held to express the new industrialized society, as an analogue to machines themselves. Second, the Bauhaus style was claimed to be simple, hygienic and affordable, thus improving the quality of life for the masses. And thirdly, the style represented a collaboration between individual designer-craftsmen and industry. The individual designer suppres-sed her desire for idiosyncratic self-expression, for the higher purpose of

serving society. If there is an anonymity in late Bauhaus design, it was fully intended.

What you have is an ideological shift away from Ruskin's concern for the labourer at work. The Bauhauslers apparently assumed that mass-producing their designs in some factory would be bearable, at least. I have never found a single reference to the quality of labour, when it comes to the Bauhaus products. Instead, the Bauhaus, in spite of its socialist leanings, focused attention on the labourer at home, as consumer. Presumably, the labourer would be made happier by having his Bauhaus chair, lamp, table and carpet. And, it should go without saying that the Bauhaus emphatically rejected the historicism of William Morris's medievalism. According to the theory, modern style could not accommodate history.

It was the alignment of modernity and handwork that produced the second reinvention of craft, particularly in the United States. Some of you may be familiar with the story about U.S. servicemen and women returning to civilian life in the late 1940s and the passage of the "GI Bill." This legislation provided a free college education to any ex-soldier who wanted it, and one result was an exponential growth in craft education at the college level in the U.S.

Many of these ex-soldiers were deeply suspicious of the regimented life in the armed services and were looking for an honourable vocation in which they could remain relatively independent and be their own boss. In addition, those soldiers with some visual sophistication were stimulated by the ferment in postwar artistic culture. This was the era of "free art" and "free jazz," when the European avant-garde met the native culture of be-bop. Art and music were throwing off the conventions of representation and orchestration: the new art was abstract and improvised. To be an artist was to be a pioneer. In this atmosphere, craft work offered a way to participate in the new visual culture without having to starve: a marriage of art, self-determination and business.

The story of the metalsmith Ronald Pearson is not unusual. After a stint in the merchant marine, Pearson took classes at the School for American Craftsmen, but never graduated. While still a student, he bought an old spinning lathe, made a chicken coop into a studio, and went into production. At different times he was a retail shop owner, designer for a large jewellery manufacturer and operator of his own jewellery production company. All of his work was informed by the prevailing tastes in modernism: simple, elegant, and adventurous. Like Jack Lenor Larsen, John Prip, Harry Bertoia and many others, Pearson could produce his own work and also design for industry. He worked comfortably in the marketplace, making objects for interiors, for the home, and for personal adornment. Pearson was a true "designer-craftsman," in the sense promoted by the Bauhaus.

A slightly later development was the idea of the "artist-craftsman." In this model, the craftsman looks to the artworld for a stylistic or conceptual framework. Of course, in the 1950s, that meant abstract expressionism.

And obviously, in American crafts, the most prominent example of a crafts-
man embracing the ethos of Ab-Ex is Peter Voulkos.

Voulkos started out as a talented and somewhat iconoclastic potter.
The story goes that Voulkos taught a ceramics course at Black Mountain
College in the summer of 1953 and then visited New York as a guest of M.C.
Richards. There he met Franz Kline, Philip Guston, Robert Rauschenberg
and others, and got a close-up look at New York School painting. Back in
California, he started to punch and rip and stack his clay, making pots that
can only be described as abstract expressionist. Like an "action painter,"
Voulkos would energetically throw his medium around, improvising until he
achieved a satisfying abstract composition. Presumably Voulkos's pots
expressed some agitated inner state, and there are dozens of pictures of
Voulkos at the wheel, grimacing wildly, making sure his audience knew he
was chock-full of untamed emotion. These pots exploded on the national
scene in the fall of 1956, featured in a major *Craft Horizons* article. Crafts
have never been the same.

I should point out that Voulkos, like many of the artist-craftsmen (and
-women) who followed him, was subsidized. He taught from 1954 until 1985
and the teaching job afforded him a great deal of freedom and flexibility. It's a
lot easier to be an artist when you have a regular paycheque coming in.

I also find it interesting that the socialist leanings of English Arts and
Crafts and of the Bauhaus were rarely taken seriously in the United States. In
fact, I don't believe anybody, anywhere, seriously thinks craft can be an effec-
tive agent for inciting socialist revolution. The grand overhaul of society
envisioned by Morris and many others seems to have become a dead issue.
Perhaps a few craft practitioners think that their work can be a reminder that
social justice is still a noble and necessary goal. However, I believe most
craftspeople think about personal empowerment: they see craft as a means to
control their own production. Craft gives thousands of people the dignity of
their own labour and a certain degree of independence. As I see it, these are
the goals of Ruskin's critique, achieved on an intimate scale and without
overthrowing the system. The craft studio represents capitalism with a human
face.

At any rate, the two paradigms that I have described – that of the
craftsman-businessman, and that of the craftsman-artist – remain the two
most influential models in North American craft today. One model is a bit
more beholden to a marketplace economy, and the other to an atmosphere of
theory and scholarship. Either model usually operates within the limits of
modernism or postmodernism – take your choice. These two paradigms also
describe a schism that plagues each of the craft mediums: a little war
between production-oriented craftspeople and art-oriented craftspeople. In
crude sexual terms, the business types accuse the art types of masturbation,
and the art types accuse the business types of prostitution. Most outsiders
find the quarrel incomprehensible, but it has parallels in almost every profes-
sion. It's true, however, that craft-as-art gets more institutional perks.

Teaching, writing, exhibitions, museum collecting and even symposia like this one are all heavily skewed in favour of craft-as-art.

I should also mention that there are other paradigms available: craft-as-hobby, craft-as-replication (like the furniture makers who produce perfect reproductions of Shaker cabinets or Windsor chairs), or craft-as-vocation (like trade jewellers or farriers). Each of these types of craft generates its own subculture with its own values, rules, heroes and villains. I find all of them interesting, but I must confess to knowing very little about them.

A Reminder

At this point, I want to make a few remarks about history in general, and craft history in particular, because we are here to produce both a record of our collective past and an agenda for our collective future. History impacts on both activities. History is a construction. It is the imposition of a narrative on the chaotic jumble of events. It seeks to impose an order which may be entirely synthetic, and is subject to the whim and politics of the historian. It is backward-looking by nature: it is a survey of what has already happened. History cannot predict the future, but it can give us some useful signposts for navigation.

In my experience, history usually consists of two basic activities. The first is editing. Whoever tackles the business of history must select some items for consideration (and thus preservation), while ignoring far more. The historian cuts and cuts, and the little bit left over makes it into the article, speech or book. The editing is ruthless.

The second activity basic to history is writing. History is written, and usually appears as a text on a page. Or, as Wendell Castle once said to me, history is written on the secondary market. All this means that history is not an objective report, but is coloured by theory, scholarship, politics and a cash-exchange economy. And inevitably, writing about craft is a translation from a tangible object to a text. As with any translation, something is always lost. So, I wonder: what will the history of contemporary craft look like? Who will make the cut? What will be recorded?

The obvious and cynical answer is simple: the big stars will make the history. The record will probably consist of Leach and Hamada, Peter Voulkos and Robert Arneson, Wendell Castle, Albert Paley and Bill Harper, Dale Chihuly, Libensky and Brychtová, Claire Ziesler and a few others. So far, mostly men. These choices can be seen as a cumulative sum of the number of times one has appeared in print, the number of pieces in major museum collections, and price points. Craft history almost writes itself: all you have to do is assemble the usual suspects and say it's the official record. It could easily become a history of personalities, not of objects.

Not surprisingly, this would also be a list of those who most expertly promoted themselves (like Dale Chihuly), those who were most diligently promoted by someone else (as Voulkos was promoted by Rose Slivka), or those who made the biggest objects. In the last case, maybe Arnie

Zimmerman and Howard Ben Tré both get added to the list. Most of them would be called "artists." Few of them can formulate a specific theory about the nature of contemporary craft. I suspect this is the way the history of craft will be written. I would hate to see it happen, but it probably will.

And Some Opinions

I think there could be a more serious history. Obviously, I'm engaging in pure opinion now, but what the hell. I told you at the beginning, this speech consists mostly of my personal point of view. To start with, I maintain that craft is not the same as art. Although the two categories are related, they are not identical.

A craft object must, before all else, be made substantially by hand. Obviously, most people have come to accept the use of machinery, but the essence remains. Objects that are made without substantial handwork or that are made in very large numbers by means of mechanically repetitive hand labour are not commonly regarded as craft. Tupperware, tennis rackets, automobiles or folding chairs: we don't think of these things as being craft.

Craft also depends on the respective mediums, techniques, formats and histories that are traditionally associated with its disciplines. "Ceramics" implies the use of clay, the techniques of working clay, traditional forms of clay objects like the vessel, and the long pan-cultural history of clay objects. Each craft medium has its own list of traditional associations. Of course, while part of the twentieth-century craft enterprise has been to adapt new techniques (like electroforming), new formats (like computer stands), or even new materials (like plastics), the traditional associations still constitute a centre for craft. I would say that it's not a matter of either/or but a matter of degree. There are degrees of craftness. The more an object manifests traditional craft mediums, techniques, formats and history, the more craft-like the object is.

Obviously, many of the most interesting objects in the craftworld today are hybrids: they take characteristics of both craft and art. There are craftspeople who make installations, craftspeople who make useless objects from found objects, craftspeople who put on performances. But the less an object manifests the craft attributes I mentioned, the less of a craft object it is. Thus, there are some things that I don't think are craft in any meaningful way. For instance, in 1975 Margie Hughto invited a series of painters and sculptors to work in clay at Syracuse University. One of the results was Larry Poons slinging wet clay at a wall, in a manner similar to the way he was handling paint at the time. It might have been an interesting event, but I don't think it was craft in any meaningful sense.

That is to say, craft has inherent limits. Craft must retain a sense of the object; craft must be substantially handmade; craft might engage its own traditions, but craft cannot fully partake of the openness of contemporary art. Craft cannot be just anything at all.

I find Arthur Danto's thesis about contemporary art to be very useful. Danto, a philosopher, found Andy Warhol's *Brillo Box* to be very interesting.

He couldn't find a way to visually distinguish Warhol's box from the real thing – let's say he doesn't have a craftsman's eye for detail – and he started searching for a definition of art that would encompass the fact that, in this century, art is often indistinguishable from plain old, everyday objects. His solution had two parts. First, Danto determined that art is embodied meaning. That is to say, the only thing that ties together all the many and varied types of late-twentieth-century art, from paintings to performances, is that they all signify some kind of specialized meaning. Danto also proposed that there is a community that is equipped to decode these meanings, and he called it the artworld. But the upshot of Danto's thesis is that art can be anything at all. (Danto has a wonderfully patrician way of saying it: "Art can be anything ah-tall.") As far as I can tell, Danto's thesis works. It's an accurate and inclusive way of describing the whole range of contemporary artwork.

But if craft cannot be anything at all, it must be philosophically different from art. Most of my colleagues think I'm splitting hairs when I make this assertion. The usual response is to suggest that craft can embody meaning, too, and therefore art and craft must be philosophically the same. But I don't think so. Danto's thesis proposes an open-endedness that is not available to craft. By its nature, I believe craft must have limits, and those limits are philosophically significant. Exactly how, I'm not enough of a scholar to say just yet.

In the past fifteen years, many observers of contemporary craft have suggested that art and craft have merged or should merge. Implicit in such assertions is that, philosophically, craft as we know it and art as we know it are the same thing. But in an atmosphere wherein art is regarded, in essence, as a conceptual activity – as the embodying of meaning – I think that arguing that art and craft are the same thing is wrong.

The conceptualist bent of contemporary art is blind – utterly blind – to some of the most important attributes of modern craft. The artworld has no use for the fact that craft objects are made by hand, and that learning a craft is difficult and demanding. Within the artworld, "craft" is typically regarded as mere skill, incapable of embodying a consistent artistic vision or a complex philosophical statement. Furthermore, the artworld has nothing but contempt for the way most craft objects are designed to be used in a domestic setting or the way that craft objects are frequently employed in the non-monetary economy of gift-giving. Nor does the artworld value the many histories of craft, except when a certified artist might condescend to call attention to them. Although these many dismissals of craft attitudes and craft values are breaking down, they are still commonplace in artworld capitals.

Thus, it's my contention that any discourse on craft history or craft theory that looks to art for its philosophical framework or its vocabulary or basic themes is doomed to misrepresent its subject. If craft and art are not the same, then craft history and art history cannot be the same, craft education and art education cannot be the same, and craft theory and art theory cannot be the same.

It's my hope that this symposium will dwell upon those aspects of craft attitudes, practice, theory and education that have no counterpart in the artworld. I would hope that the other speakers here focus on those attributes of craft that are different. Too often people habitually interpret differences as signs of inferiority – or superiority. However, differences can simply denote a shift in category or a change in attitude. As craftspeople, we don't have to cringe or boast. But I think it's imperative to underline the differences between craft and art.

As I said, craft is a recent invention, even as it has roots in pre-industrial technology. That combination of social awareness and respect for tradition gives modern craft a unique identity, one that is rarely explored.

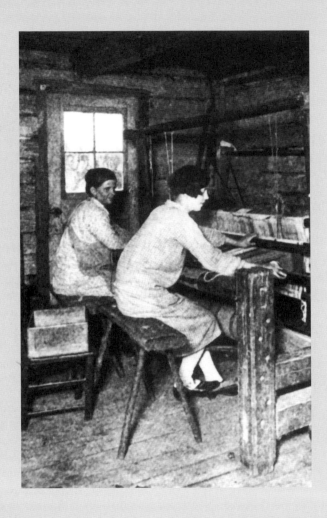

"In this log cabin, grandmother and mother
are at work at a wide homemade loom."

Courtesy: Canadian Geographic Journal, Jan. 1933

Dr. Sandra Flood has exhibited, taught, curated, juried and written about craft. Her doctoral thesis, *Canadian Craft and Museum Practice 1900–1950*, is published in the Canadian Museum of Civilization's Mercury series. Flood continues to research Canadian craft activity from 1950 to 1999.

Craft in Canada: Overview and Points from *Canadian Craft and Museum Practice 1900–1950*
Dr. Sandra Flood

Research into craft practice in Canada – as with research into craft practice elsewhere in the Western world except perhaps Australia – is sparse, localized, uneven, and content is largely restricted to region, medium or maker. Much of the little research there is has gone unpublished. There have been no bibliographies, and library classifications have over thirty-four categories and subcategories under which craft information can be found, including the category "handicrafts." This makes searches a marathon of frustration. Research beyond one's immediate region becomes more and more difficult as archives pitch cost-recovery at corporate or government rather than student budgets, interlibrary loan costs rise and book titles become so flowery that they are little guide to content. In addition, there seems minimal academic support for craft history per se. Although it may creep in under other rubrics, it is denied recognition in its own right. It is almost impossible to get funding to do solid and sustained research in Canada. As a result we are losing material evidence, archival and other resources because they are perceived as being of little or no value. And this is in part the fault of the craft community and the current mythology that "nothing happened here in craft until the late 1960s, early 1970s" with the corollary "until the Americans arrived."[1] How easily we allow ourselves to be colonized! The underlying premise to these remarks is that if anything did go on it was not worth considering, an anti-historical attitude which bodes ill for the longevity of current work.

Between September 1994 and June 1998, I researched and wrote a doctoral thesis entitled *Canadian Craft and Museum Practice 1900–1950* through the University of Manchester, England. I must gratefully acknowledge that my department there got me one of twelve Manchester University studentships, which kept me afloat financially over three years. The research was done while I was based at the Canadian Museum of Civilization, Hull, as a research associate, an unsalaried position.

My thesis is the first survey of pan-Canada craft activity in the first half of the twentieth century. As a result, the questions I asked were basic – what actually went on, where, and who was involved? Because I was working out of a museums studies department at Manchester University and because museum collections are perceived as the collective memory in relation to a country's material culture (they certainly assign cultural and economic value to practice), I looked at the Canadian museum community and its relationship to the craft community.

In this very brief talk I am going to concentrate on craft activity rather than museum activity. This is partly because, as it transpired, with the exception of the anthropologist Marius Barbeau at the National Museum of Canada (now the Canadian Museum of Civilization), who focused on rural Quebecois work from 1925 on, our museums appear to have taken little interest in craft. The collecting of contemporary Canadian craft started as early as 1908. Ten of the thirteen craft collections I identified between 1908 and 1950 were associated with craft organizations or institutions. These craft organizations were initiated and run by women and – with the addition of Alice Webster, a patron and honorary curator at the New Brunswick Museum, who set up a decorative arts and crafts collection there – nine of the thirteen collections were generated by women. Of the thirteen collections only three still exist as identifiable collections – the Barbeau collection at the Canadian Museum of Civilization; the collection of the Canadian Handicrafts Guild: Manitoba Branch, later the Manitoba Craft Guild, now existing somewhat precariously as the Manitoba Craft Museum; and the Ukrainian Women's Association of Canada: Ukrainian Museums. The rest have been lost, dispersed or have disappeared.

There are two far-reaching effects of this lack of recognition of craft by museums. The first is to deprive craftspeople, unlike artists and aboriginal peoples, of official recognition of their activity and products as an intrinsic and valued part of Canadian cultural life. The second is to deprive the craft community of material evidence of its history through museums' unwillingness (or inability) to accommodate collections put together by craft organizations. The astonishment of the Royal Commission on National Development in the Arts, Letters and Sciences 1949–1951, the Massey Commission on national development in the arts, letters and sciences, at finding crafts presented for its consideration reflects the elitist, compartmentalized, official perspective: "to none of us ... did it occur that we should be receiving submissions on heraldry, chess, numismatics, mediaeval studies, town planning, folklore, zoological gardens and handicrafts."[2] The Massey Commission did have the grace to admit after receiving forty-four presentations on craft that "there is no doubt that handicrafts are an important activity of Canadian citizens,"[3] although they continued to discount it.

Before launching into this preliminary survey of pan-Canadian craft activity, nothing had led me to suspect the wealth and diversity of activity that I was to find. At this point I have not done a comparable survey of craft from

1950 on; however, viewing my research in combination with such factors as fashions, education, continuing artisan practice, population size and lifestyles in the first half of the twentieth century, it is conceivable that prior to 1950, craft practice at a very high level was more widespread, craft making and craft organizations were higher profile and exhibitions and marketing were less provincial than is currently the case.

My thesis covers the historiography of writing about craft within the period, including an analysis of the writers – the voice of the craftsperson is rarely heard – and the key issues of loss of skills, craft in the national economy, the contribution of craftspeople to industrial design, the craft-versus-machine discourse arising from the Arts and Crafts movement, craft and rural life, national art, racial unity, universality and, of course, the place of craft in the fine art hierarchy. Who wrote about craft and the way in which it was written about contributed to a distortion of the perception of craft and craftmaking.

The thesis surveys craft making for a living, craft in the domestic economy and craft as a leisure activity. This latter designation, during decades when social mores dictated that most women, and particularly married women, would not take paid employment, often covered a more serious commitment. A newspaper report referring to a group of women making pottery in Victoria, B.C., in 1927 said: "It is expected that the government will start work shortly on a large community kiln where women can fire more ambitious pieces than they have been able to handle heretofore, urns, fountain decorations, bird baths and other things suitable for gardens."[4] They hardly sound like dilettantes.

The thesis looks briefly at the increased role of craftswomen and craftmaking. Growing numbers of unmarried art-school trained women were looking for a career in the expanding general education system and in occupational therapy, a new option fed by the casualties of two world wars and a more enlightened attitude to mental illness.

My research looks at "cottage industries," at craft organizations, at government intervention in craft production through rural women's organizations and through governmental small industry and marketing departments, which of course gave rise to government reports on craft. My thesis also examines formal craft education at art or technical schools which came into being in seven provinces between 1884 and 1925, documenting their highly qualified staff, their programs and histories. Lastly, I have reviewed the definition and practices of studio craftspeople (as compared with others making a living from craftmaking), referring to social class, education, income generation and self-concept through the developing associations of craftspeople or media specialists.

This range of activity indicates a craft community that was large, diverse and fragmented. Its diversity extended through ethnicity, class, craft education, production circumstances, products and rationale for making. In other words, it was a group of communities, each group operating independently

but with limited intercourse and areas of overlap between groups. From today's viewpoint little has changed.

From the beginning of the twentieth century, work in all media was taking place, although emphases changed over the first five decades. For example, Vancouver's Opening Exhibition in 1910 had an astonishing thirty-five categories for lace and twelve classes for rugs, although rug-making is thought of exclusively in relation to Eastern Canada. There was also wood carving, furniture, pottery and glass blowing. Batiks were already being exhibited in 1919 and were really big, literally and metaphorically, in the 1930s. Who was Hilda Benjamin Sexton, the creator of two large embroideries, *The Hunt* and *The Seasons,* exhibited at the Canadian National Exhibition, Toronto, Applied Arts Exhibition, at the end of the 1920s, valued at $2000 each? And how many weavers were there like Marie Wells, a homesteader's wife from Glenbush near the Saskatchewan-Alberta border? A weaver of silk and silk-and-wool lengths, she who wrote to the Saskatoon Arts and Crafts Society in 1923:

"I have 2 more silk tunics and a skirt length that I could send. I can weave to a width of 34 inches on my loom but the idea is this – to make a garment that cannot be bought in an ordinary store something different from the usual line of goods – I never make 2 alike in every respect."[5]

In fact, if my research has begun to fill in a picture, mark out its dimensions, it has also flagged the many areas that need more research. In looking at all these areas of activity I was highly aware that Canada between 1900 and 1950 was still becoming Canada. Confederation in 1867 was merely the joining of the four original colonies, Nova Scotia, New Brunswick, southern Ontario and southern Quebec – Canada West and Canada East. At the beginning of the twentieth century the major internal boundaries were not in place and the influx of peoples into the vast area of Western Canada had only just started. In 1901 there were just over five million Canadian residents; a decade later there were more than seven million. By 1921 the prairie population had risen from 7% to 22% of the Canadian population and contained 24% of foreign-born Canadians, marking a major change in regional and ethnic population balances.

Amid this melee of boosterism, disruption, settlement and cultural and economic disparity, three trends are notable. First commentators on craft, viewing from Central Canada the ongoing influx of "foreigners" (Europeans and others) and concerned with the need to create a stable and civilized nation, saw craft as having a unique, perhaps pivotal position, in constructing a national image, in nation building and in providing a common meeting ground between different ethnic groups. Moreover, in the revival and encouragement of crafts, an art foundation was being laid for Canada. William Carless, a professor of architecture at McGill University, said in 1925 that craft was "a matter of national importance ... keeping alive those art traditions which have grown up in this country in the past ... [and] those also which are

continually being brought in by immigrants is an essential part of the fabric which some day may go to make up a distinctively Canadian art."[6]

By 1944 the federal government in its "Review Statement Outlining the Work and Recommendations of the Provisional Interdepartmental Committee on Canadian Hand Arts and Crafts" had given that sentiment a slightly different twist, reiterating: "a national-scale encouragement of useful creative talents offers a common denominator of interest to all Canadians which may be considered independent of provincial, economic, social, racial and political differences. ... such a non-contentious subject offers unique opportunities for developing a *nationally appreciated and internationally distinctive Canadian home culture*."[7]

Secondly, by the end of the first decade of the twentieth century, there was already a national craft organization energetically exhibiting, promoting, marketing, educating and collecting craft. This was probably the first such organization in the Western world and, given the state of transportation and communications at this period in this vast, sparsely settled country, it was a remarkable achievement. By 1906 when the Canadian Handicraft Guild was incorporated, the Guild already had for nearly a decade been organizing exhibitions and sales including two major craft exhibitions in Montreal that helped raise the support and capital to open their shop (which still exists). By 1909 craftspeople from Prince Edward Island to British Columbia were sending their work to the Guild for exhibition or sale. The Guild had been involved in reviving cottage industries in Quebec, had addressed various Government committees and was in the process of setting up a national network of sale outlets and Guild branches. In 1910 May Phillips, a co-founder of the Guild, visited fourteen centres in Western Canada, one of many trips by early Guild organizers across the Dominion. In 1904 the Guild had sent the first of the international exhibitions requested by the Canadian government to the St. Louis World Fair. Exhibits were mounted internally too; in 1906 exhibits were sent to sixteen centres in central and eastern Canada. In 1908, Alice Peck started putting together a collection of Canadian crafts, housed at the Montreal Museum of Fine Arts, encompassing Inuit, Indian, New Canadian, Quebecois and other work. This Guild, run by energetic, visionary women volunteers, put millions of dollars into craftspeoples' pockets over the five decades.

A third aspect of the twentieth-century craft milieu was that the constant stream of immigration brought skilled craftspeople, from expert exponents of traditional techniques, motifs and products to graduates of renowned schools and workshops, working in every craft media. Many of these craftspeople found a niche and contributed to the richness of the Canadian scene.

Another dominant context is the economic one. Canada through the first half of the twentieth century was not only a developing country, it was a country in which wealth and industry were shifting from the Maritimes to the Montreal area and thence to the booming industrial economy of the Ontario urban horseshoe dominated by Toronto. Canada had also taken part in two

world wars and suffered the Depression and, in western Canada, the droughts of the Dirty Thirties. The rural areas, in particular in the Maritimes and Quebec, were in constant economic crisis. These crises gave rise to a number of individual initiatives in creating "cottage industries." Cheticamp, Cape Breton Island, hooked rug production, revamped by the American art teacher and occupational therapist Lillian Burke in 1927, was one of the most famous initiatives (another being the Charlotte County Crafts, started by the New Brunswick artist Helen Grace Mowat in 1914) and still continues to this day. These were but two of many projects, and not only in eastern Canada: for example, Mrs. Barber at Craft Cottage, Port Hope, B.C., by 1941 had "built up a centre where skilled workers wove woolen and linen fabrics on hand looms."[8]

This cottage industry aspect of craft production attracted the interest of the urban, middle-class commentators on the craft scene, causing a shift in the perception of craft, not least by governments. Alice Peck, a co-founder of the Canadian Handicrafts Guild, recalled the Guild's universal commitment at the beginning of the century: "to reviving and making profitable all such crafts as could be carried on in cottage or castle, in town or in the remotest parts of the country."[9]

But by 1938 Wilfrid Bovey, President of the Guild, was firmly linking craft to rural life: "It is not surprising on the whole we look to the country rather than to the city for our craftsmen and women. To say that handicraft cannot thrive in cities would be ... wrong ... but handicrafts ... thrive better in country air. There are economic reasons, but ... the art of which handicrafts are an expression is essentially part of Canadian rural life. The independence of the handicraft worker is the independence of the farmer; the scenes that the rug-maker depicts are country scenes, the tweeds from the weaver's loom exude country air."[10]

Georges Bouchard, who was a co-founder of the Cercles des Fermières in Quebec in 1909 and by 1941 was the provincial assistant deputy minister of agriculture, acknowledged the official agenda that young farm women with "the tenderness of their rustic hearts and the candour of their ingenuous souls" should be "kept from the lure of idle dreams, the seduction of the catalogues and the attraction of the big cities."[11]

Through this romantic rural writing, the grossly low price paid for craft work became justified by such intangibles as its being a good use of time and satisfying work. The comment page of a 1941 Federal Government report "Composite Report to the Minister of Agriculture concerning some values to be derived from an National Handicraft Program" says: "The privilege of being able to work at a craft provides the worker with the undeniably real and well-earned feelings of satisfaction and contentment – the more or less abstract feelings of general contentment make quite unnecessary and, indeed, undesired countless services and possessions which others feel so all-important in order to secure and keep a place in society."[12]

The report omits to mention that many of the generic "craftsmen" were actually craftswomen, which perhaps accounts for the casualness with which inadequate financial recompense for skilled work was treated. This leads me to a final point I would like to make about this research. I did not anticipate the extraordinarily high level of women's involvement in all aspects of craft throughout the period, as presented in the literature and through archival records. There certainly was no intent to write a gendered account. Further research may redress to some extent the gender balance of makers but not, I think, in other areas. Feminist re-evaluation of male-generated histories and practice has led me to speculate that the association of women and craft in the eyes of the male world of government and museums may have seriously undermined craft's status and credibility, and distorted its history. My research aimed to redress this distortion through a fresh look at data that recovers the dimensions and vitality of craft and its influences and importance in the first half of twentieth-century Canada.

Notes

1. A senior member of the British Columbia craft community during a discussion at the Canadian Craft Museum, Vancouver, October 21, 1996

2. Massey, V. et al., *Report: National Development in the Arts, Letters and Sciences*, (Ottawa: King's Printer, 1951), p. 139

3. Ibid., p. 235

4. De Bertrand Lugrin, N., "Women Potters and Indian Themes," *Maclean's Magazine*, March 15, 1927, p. 79

5. Saskatchewan Archives Board, Saskatoon, Saskatoon Arts and Crafts Society fonds, B88-E(1), correspondence 1922–24, Marie Wells-Glenbush to Mrs. Marshall, September 20, 1923

6. Carless, W., *The Arts and Crafts in Canada*, (McGill University Publications Series, Art and Architecture, Montreal: McGill University Press, 1925), pp. 4–5

7. Russell, D.H. et al., "Review Statement Outlining the Work and Recommendations of the Provisional Interdepartmental Committee on Canadian Hand Arts and Crafts," Ottawa, 1944, p. 4

8. Green, H.G. *A Heritage of Canadian Handicrafts*, (Montreal: McClelland & Stewart, 1967), p. 219

9. Peck, A. "Handicrafts from Coast to Coast," *Canadian Geographic Journal*, 9:4:204, October 1934

10. Bovey, W. "Survey of Domestic Art and Craft in Canadian Intellectual and Economic Life," (Montreal: Canadian Handicrafts Guild, 1938), p. 9

11. Bouchard, G. "The Renaissance of Rustic Crafts," *Scientific Agriculture*, reprint, Ottawa, 1937, p. 5

12. Russell, D.H., "Composite Report to the Minister of Agriculture concerning some values to be derived from a National Handicraft Program," Ottawa, 1941, n/p "Comment"

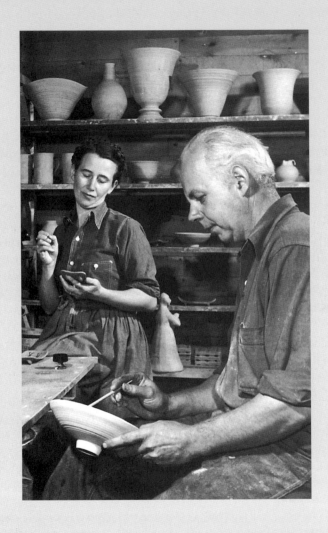

Kjeld and Erica Deichmann glazing pots
Photo: National Film Board of Canada

Alan C. Elder is curator, Canadian crafts, decorative art and design, Canadian Museum of Civilization. He has produced many exhibitions of art, architecture, craft and design including *Transformation: Prix Saidye Bronfman Award 1977–1996* and *Designing a Modern Identity: The New Spirit of British Columbia 1945-1960.*

Reflecting and Affecting Craft: Federal Policy and Contemporary Canadian Craft
Alan C. Elder

In the book *NAFTA in Transition* John Herd Thompson of Duke University stated that "the most characteristic Canadian promotional response to the conundrum of cultural sovereignty was the creation of a publicly funded infrastructure."[1] In this paper, I examine two Canadian federal studies that have both reflected and affected the position of crafts in Canada in the period following the Second World War. In doing this, I do not assume that these studies were the only or even most important factor affecting the status of the crafts – either in their own time or today. However, in a country that has a history of government support of the arts, public policies deserve some consideration, as cultural policy is both a reflection of the status quo and a vision of the future.

In the earlier years of the century, crafts and craftspeople played an integral role in the Canadian artistic community. An example of this integrity is the role of Kjeld and Erica Deichmann within the cultural landscape. The Deichmanns were a husband-and-wife team who produced figurative and functional ceramics in rural New Brunswick from the 1930s to the early 1960s. Shortly after they had established their studio, they received an invitation from a group in Toronto. It read:

"We – the Canadian Guild of Potters, as the group is now called – have been invited to make an exhibit of pottery for Paris, starting 1 May [1937] and running for six months. There is to be a hut of some sort erected and the arts and crafts of Canada will be exhibited within. The pottery will be selected by Dr. Marius Barbeau, a government official from Ottawa, from our museum display at the end of the month. I shall advise you later how many pieces and what pieces of yours will be sent to Paris."[2]

This invitation, and the nature of the resultant exhibition, indicated the breadth of "artistic activity" that was considered to be important for display abroad. The selection included both those objects that could be considered

"fine arts" and those "crafts." Exhibitions like this one were not the exception to the rule. Other exhibitions, as well as journals, documented the inclusion of craft-based works in examinations of artistic practice. The Deichmanns were part of an artistic circle that included artists Pegi Nicol MacLeod and Miller Brittain.[3] This interdisciplinarity of visual art forms reflected a nation that was struggling to establish itself on the world stage. A solidarity within the visual arts was needed to represent Canada as a united force.

The Massey Commission

Between 1949 and 1951, the Royal Commission on National Development in the Arts, Letters and Sciences – commonly known as the Massey Commission after its chair, future Governor General Vincent Massey – surveyed the cultural activities of Canada and, after travelling from coast to coast, made significant recommendations that altered our cultural policies. The Commission felt that Canadians should know as much about their country – its history and traditions – as possible. This interest in developing a strong national culture was important for a country which had recently demonstrated its autonomy as a separate nation in World War II rather than as part of the British forces. Significantly, craft did not form part of the original mandate of the Commission – other than craft's exhibition at either the National Gallery of Canada or the National Museum (now the Canadian Museum of Civilization) However, the Commissioners did include a chapter on "handicrafts" in its final report – along with other areas of interest not covered in the original mandate. Concerning the original exclusion of craft and its later addition, the Report stated that:

"We were, however, promptly informed about the diversity and energy of our fellow-citizens, and we recall with particular pleasure the spirited and good-humoured assaults made upon us by societies and individuals concerned with the fostering and growth of Canadian handicrafts."[4]

The commission admitted that the term "craftsman" was used loosely to include full-time professionals, amateurs, invalids and hobbyists. It was completely assured that craft was an important activity for the nation's citizens.[5] However the commissioners' recommendations for the craft community – as distinct from art – left them in an ambiguous situation. They concluded that the "formal encouragement of handicrafts is a responsibility of the provinces and of various voluntary organizations," particularly the Canadian Handicrafts Guild which had been incorporated in Montreal in 1906 and had (at this time) branches in Alberta, Manitoba, Ontario, Quebec and the Northwest Territories.[6]

Unlike what they proposed for other disciplines, the commissioners decided not to make any formal recommendations for craft. They believed that craft in Canada could be most effectively and suitably aided through the strengthening of the national voluntary organizations – including the Canadian Handicrafts Guild. The support for this voluntary organization, like that for

other groups, could come from the proposed "Canada Council for the Encouragement of the Arts, Letters, Humanities and Social Sciences."

The dichotomy of the recommendations – including moral support but no formal strategy – reflected the increasingly ambiguous relationship between art and craft. The Commission had seen Canadian painting "through its honesty and its artistic value, become above all other arts the great means of giving expression to the Canadian spirit."[7] The two areas – the fine arts, as exemplified by painting, and craft – were moving away from each other, contrary to the Bauhausian concept of interdisciplinarity that was practiced at many of the art schools across the country. Whereas earlier exhibitions had juxtaposed works in different media, now exhibitions considered these media separately.

Federal Cultural Review Committee

In 1982, another committee was given the task of assessing Canadian cultural policies. Louis Appelbaum and Jacques Hébert headed this committee that looked at the existing support structures and made recommendations for changes. Unlike the Massey Commission, which had a manageable five members, the Federal Cultural Review Committee had eighteen. According to the late writer George Woodcock, this committee featured "an over-crowded membership that included artists and arts entrepreneurs, cultural bureaucrats, cultural industrialists and the usual scattering of Liberal party faithful gaining their rewards."[8] Perhaps this large membership predicated a report that lacked the clear vision of the Massey Report. However, the committee members did agree that "the applied arts and crafts were under-represented in present museum collections."[9] Fortunately or unfortunately, this committee's recommendations were not as well accepted as the ones proposed by Massey and his cohorts. The Committee stated that: "The Canada Council deals with the applied arts [which they defined as including unique crafts and industrial design] only peripherally. The utility that is an important discipline to creative designers usually places their work outside the Council's terms of reference."[10]

Canada Council for the Arts

In order to provide funding for applied arts, the Committee recommended the establishment of a Canada Council for Design and Applied Arts by amending the National Design Council Act of 1960. (The Design Council existed in name only at this point.) It also recommended the provision of funding to a level that would enable the Council to fulfill its mandate.[11] This recommendation about the provision of funding and their acknowledgement of the lack of museum collections demonstrated the committee's belief in the importance of craft and design. Their call for a separate council reflected the growing divide between perceptions of what craft is and in what context craft belongs. Craft was, and is, more than design alone (and more than fine art alone). It represented multiple approaches with varied goals. Had this recommendation been

accepted by the federal government, the separation between art and craft might have been even greater, even if its allegiance with design had been strengthened.

As it stands now, responsibility for federal funding of the fine arts, architectural design and craft is held by the Canada Council for the Arts. (Provincial funding varies from province to province. A separate study of the provincial support structures could provide insights into the differing states of craft in various regions.) The Council's support for craftspeople did not come easily. Over ten years ago, the Chalmers family endowed the Council to assure its support of craft projects. And through the "good-humoured" (and perhaps not-so-good-humoured) assaults by another generation of craftspeople, the Council has reinforced craft organizations' and individuals' ability to apply for visual arts grants. The incorporation of craft into mainstream visual arts funding programs has been supplemented by special allocations. Craft and fine arts have yet to be fully integrated through federal cultural policy.

Constructing a National Identity

How do we look forward? What factors will affect cultural policy in the future – including, and perhaps particularly, craft? We have seen in concrete form – most notably through Sheila Copps's battles with the American magazine industry – the integration of culture into issues of national identity, and how that integration is unique in its conception to Canada. Returning to John Thompson's article about the affects of NAFTA, he says: "The convergence of U.S. and Canadian understandings of 'culture' may hold greater peril for Canada's cultural sovereignty than any threatened U.S. retaliation to specific Canadian policies of cultural protection and promotion."[12]

For Canadians, "protecting our culture" means protecting aspects of our lives that constitute our nationality – what we read, see, hear, watch and, if we take the example of craft, touch. What constitutes our national identity and culture has always been in question, in flux. But never has it been more in question than at the present. The Massey Commission quoted the words of Saint Augustine in the introduction to their report: "A nation is an association of reasonable beings united in a peaceful sharing of the things they cherish, therefore, to determine the quality of a nation, you must consider what those things are."[13]

One of the common ideas about Canada is that it is a country that embraces its lack of fixed identity.[14] Canadians frequently describe themselves as multicultural, as a "mosaic" of equally valued cultures rather than as an American "melting pot." Anthony Wilden, a Vancouver-based communications theorist, has described Canadians as living in "Notland, where being Canadian means not being someone else – not English, not American, not Asian, not European."[15] Identities can be seen as being formed in opposition to a dominating "other" – in Canada's case, the United States. "It is easier," noted Vincent Massey in his treatise, *On Being Canadian*, "to say what Canada is not, than what it is."[16] But as Jacques Derrida and Jacques Lacan

have noted, to define oneself by what one is not is how subjectivity is formed. And if, as Louis Althusser asserts, the power of ideology comes from its seeming absence or perhaps its transparency, it is the invisibility of those "nots" that aids in the construction of a Canadian national identity.[17]

The construction of national identities is a fairly recent phenomenon. Some think that, because Canada lacks a long history, we cannot have a strong identity. Others feel that issues of national identity have passed as we enter into an e-world of globalization. Perhaps we need to think of Canada as being comprised of an assemblage of communities instead of constituting a single, monolithic identity. Benedict Anderson, in his book *Imagined Communities*, explains why he refers to contemporary communities as "imagined." He says, "It is imagined because the members of even the small-est nation will never know most of their fellow-members, meet them, or even hear of them, yet in the minds of each lives the image of their communion."[18] It is this "communion" that establishes a network for the exchange of infor-mation and ideas about identity. And it is this imagined community that combines specific, national history with transnational ideas to produce works that have the power to hold their own within an international forum.

Borders

In November 1998, I was invited to present a paper (similar in scope to this one) at a symposium hosted by the American Craft Museum in New York. The symposium was entitled "Craft at the Border." At that time, I discussed the importance of borders on the formation of a Canadian identity. Borders have the ability to be simultaneously inclusive and exclusive. As Martin Kuester has noted in his book *Canadian Studies: A Literary Approach,* "Canada is unthinkable without its border with the USA."[19] The 49th parallel both joins and divides the two nation-states: it permits contact, influence, choice, trade and difference. But Canada is also unthinkable without its other borders – the polar border with Russia, the Atlantic border with Europe and the Pacific border with Asia.[20] Early immigration to Canada came mainly from the east – from Europe and Britain. The nation's early customs were usually adaptations of those from "the Old World." The northern frontier has provided Canadians with notions of unconquered territory; Canadians co-exist with the fury of northern nature but are unable to conquer it. The Pacific Rim has taken on greater national significance over the past decade for reasons of changing trade and immigration as well as sources of capital. Asia has influenced the way that we dress, eat and relax, as well as our aesthetics. But, like the North, the western border has also functioned more often as a periphery than as a preoccupation. For most of its history, Canada has been influenced by its Atlantic and American borders – looking east to Europe and south to the United States.

Another border that needs to be considered is not physical but tempo-ral. During a period of time that may be described as late modern or postmod-ern, Canadian identity is greatly influenced by our location in both time and

space. Feminist art historian Griselda Pollock has said that she is at home in Canada because Canada lacks a fixed identity; she does not have to limit her identity to a narrowly defined singularity.[21] It is a country that – through the influence of its borders – supports multiple identities and perspectives.

The pluralistic "Canadian" perspective differs from an "American" one that relies more on the binary: an either/or. This difference is reflected concretely when comparing the political systems of the two nations – the Canadian system that includes many parties (representing various political and regional voices) and the American system based on a two-party duality.[22] But how has this plurality affected the look of Canadian craft?

Globalization vs. The Local

In an article published on October 31, 1998, Blake Gopnik [then *Globe and Mail* art critic] commented on cultural nationalism in the visual arts in Canada. (Since the categories considered in this article were film and television, performing arts, music and radio and publishing, I made the assumption that visual arts might also include craft; Gopnik corroborated this assumption in November 1998.) In his article Gopnik stated, "The art world has become quite thoroughly globalized – national styles are on their way to extinction, no centre dominates, and no one cares where you are from."[23]

Gopnik's comment reflected the evolution that has taken place in the consideration of the proper place for craft. Over the past fifty years, we have seen a shift from Massey's concern with the development of a strong national identity – even if it was criticized as being elitist – through the Appelbaum-Hébert's support of culture as an industry, to the current situation – our place within an increasingly globalized culture. Yet our aesthetics, concerns and approaches are most often based on a combination of international goings-on and local concerns – and here "local" may be geographic or shared-interest groupings. Much more work needs to be done to research the history of studio craft in Canada. Sandra Flood's doctoral thesis about the history of Canadian craft in the first half of the twentieth century has been recently published by the Canadian Museum of Civilization; Anne Barros has published a history of Canadian metalwork, *Ornament and Object: Canadian Jewellery and Metal Art 1946–1996*; and Gail Crawford's book *A Fine Line* looks at studio craft in Ontario. In fact, a book about contemporary British Columbian ceramics is currently on the bestseller list in Vancouver. But now we need to understand where Canadian craft – with its unique history of government support and entrepreneurial spirit – stands within a broader understanding of contemporary craft. Federal policies that have impacted on craft today were informed by the aspirations of those involved in the cultural sector. As the powers of nation-states give way to a growing sense of internationalism, we are entering a new period in the formation and understanding of identity. We must try to understand, and make understood, the place of craft within visual culture and the importance of visual culture within our society.

More work needs to be done to highlight the unique qualities of individual identity and cultural production. Canada has prided itself on its encouragement of multiple points of view and a plurality of voices. Let's try to work towards a discourse that envelops the uniqueness of our history along with a broadening of our ideas about cultural production.

Notes

1. John Herd Thompson, "Canada's Quest for Cultural Sovereignty: Protection, Promotion and Popular Culture," in *NAFTA in Transition*, ed. Stephen J. Randall and Herman W. Konrad, (Calgary: University of Calgary Press, 1995), p. 397

2. Stephen Inglis, *The Turning Point: The Deichmann Pottery, 1935–1963* (Hull: Canadian Muscum of Civilization, 1991), p. 9

3. Ibid., p. 14

4. *Report of the Royal Commission on National Development in the Arts, Letters and Sciences*, (Ottawa: King's Printer, 1951), p. 235

5. Ibid.

6. Ibid., p. 237

7. Ibid., p. 211

8. George Woodcock, *Strange Bedfellows: the State and the Arts in Canada*, (Vancouver and Toronto, Douglas & McIntyre, 1985), p. 140

9. *Report of the Federal Cultural Policy Review Committee*, (Ottawa: Department of Communications, 1982) pp. 29, 111 and 135

10. Ibid., p. 162

11. Ibid., p. 163

12. Thompson, p. 410

13. From St. Augustine, *City of God*, quoted in *Report of the Royal Commission*, xviii

14. Brenda Lafleur, "Resting in History: Translating the Art of Jin-me Yoon," in Griselda Pollock (ed.) *Generations and Geographies in the Visual Arts: Feminist Readings*, (London and New York: Routledge, 1996), p. 217

15. Tony Wilden, *The Imaginary Canadian*, (Vancouver: Pulp Press, 1980), p. 2

16. Vincent Massey, *On Being Canadian* (Toronto: J.M. Dent, 1948), p. 27

17. See Lafleur, pp. 217–218

18. Benedict Anderson, *Imagined Communities*, rev. ed., (London and New York: Verso, 1991), p. 6

19. Martin Kuester, *Canadian Studies: A Literary Approach*, (Bochum, Germany: Universitatsverlag Dr. N. Brockmeyer, 1995), p. 9

20. See William New, *Borderlands: How We Talk About Canada*, (Vancouver: UBC, 1998), p. 6

21. Quoted in "Drawing Together Art's Broken Histories," *Globe and Mail* (Toronto), October 31, 1998, C18

22. New, p .42

23. Blake Gopnik, "Is the Flag Only Flapping in the Wind?", *Globe and Mail* (Toronto), October 31, 1998, C16

Contemporary Craft Theory

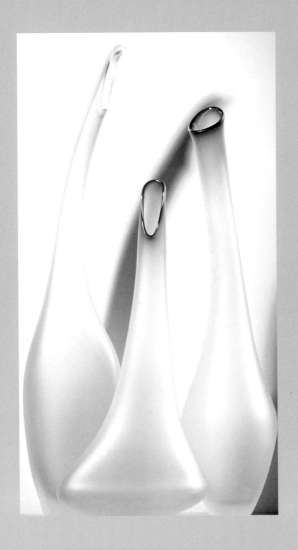

Jeff Goodman
Glass Vessels, 2000
Hot blown sandblasted glass
approx. heights 50–80 cm
Photo: Tom Feiler

Paul Greenhalgh is president of the Nova Scotia College of Art and Design and past head of research at London's Victoria and Albert Museum where he curated *Art Nouveau 1890–1914*, the largest exhibition ever staged on the subject. A historian and a theoretician of contemporary culture, he has published *Ephemeral Vistas* (1988), *Modernism in Design* (1990), *Quotations and Sources on Design and Decorative Arts 1800–1990* (1994), *Art Nouveau 1890–1914* (2000), *The Essential Art Nouveau* (2000) and *The Persistence of Craft* (2002).

Craft and Modernity
Paul Greenhalgh

I want to make a few observations about the condition of craft in relation to that most complex of phenomena: modernity. The next phase of modernity will be characterized by four things: *interdisciplinarity, globality, pan-technicality* and *eclecticism*. Those institutions and individuals in all fields of human endeavour who understand this best will be the ones who produce the most significant works in the coming decades. The world is made up of unspeakably complex and eclectic combinations of things. Through time and space, everything will impinge on everything else, in an unending, non-repeating, self-determining pattern. We swim in a sea of stuff that we have made. This stuff responds to thousands of codes, contexts and consciousnesses and fires in a million directions. These can appear to be arbitrary but they are not. I wish to make a plea for the crafts not as a worthy entity we indulge in but regard as separate from the world, but as a set of material discourses within a far bigger and ultimately more important universe. More specifically, I understand all cultural produce to be generated through a complex structured system, or infrastructure, and that this infrastructure is the key to the future of all civilization. The infrastructure is never static, but at this time, it is all in a process of significant change.

As one looks at the craft world, one could be forgiven for wondering what on earth all this stuff is about. I don't especially mean what the craft practices are about (though this is not an issue to trifle with) but rather how exactly the whole realm of visual culture, and beyond this, cultural practice generally, got to be in the condition it is. It is safe to assume in late modern culture that we can usually arrive at a social and political consensus that all the arts are worthwhile, though we collectively rarely agree to fund them appropriately. It is also important to note that we are at this stage wholly

Article continued on page 118

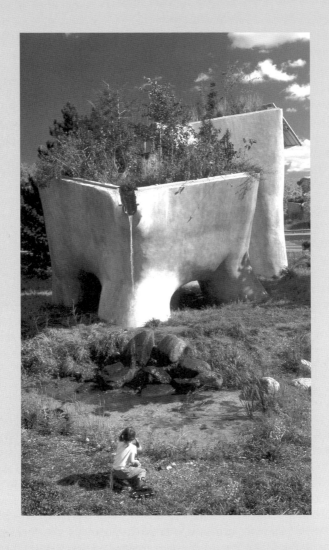

Noel Harding
Elevated Wetlands (Toronto), 1998
Six containers, plastic, composed of extended
polystyrene coated with acrylic stucco
approx. 10.5 x 16.5 metres

Ingrid Bachmann is an interdisciplinary installation artist, writer and curator who is currently researching emergent behaviours in embodied systems and networks from the field of Artificial Life as models to create generative and interactive artworks. Presently, she is the graduate program director, MFA Studio Arts, at Concordia University. She is the co-editor of *Material Matters*, a critical anthology of essays that examines the relations of material to culture.

New Craft Paradigms
Ingrid Bachmann

In this paper, I will attempt to map out a framework for the role of material or craft practices and theory in an increasingly immaterial and virtual world to outline what I consider to be the more pressing and urgent problems and lacks in contemporary craft theory and to offer new models, to propose new allegiances, and to revisit historical craft positions and traditions to see what they might offer in a contemporary context.

We are at a moment where traditional binaries in art and craft theory – high art/low art, functional/non-functional, digital/analogue, machine/hand – are no longer viable, where the imploding contradictions and distinctions between the material conditions of practice and the rhetoric that accompanies them no longer maintain their discrete autonomy but intersect, interact and collide. It is in these points of intersection and rupture between practice and theory where things get interesting.

We are in a peculiar moment at the end of a century and the beginning of a millennium, an anticlimactic moment in spite of the various doomsday prophecies and techno-utopian visions. Economically, we are in a time characterized by a brute form of pure capitalism where the bottom line has become an unquestioned justification for decisions regarding everything from economics to education to culture. We are feeling the impact of an increasingly global economy which mobilizes peoples, goods and economies at an unprecedented rate, disrupting traditions and shifting national borders. Equally dramatic is the impact of digital technology on almost every aspect of daily life in both the developed and developing worlds, as well as the impact of popular and media culture in shaping – some would say dictating – cultural values and social mores. It is an increasing reactionary political climate, where we are witnessing the reappearance and legitimization in public and political arenas of such loaded terms as "family values" and "traditional values."

Terms of Reference

I mention all this to situate craft production and theory within a broader social and cultural context. Central to this paper is a re-examination of the contemporary definition of crafts, particularly as the term has been understood in a North American and European context. My aim is to understand and identify "crafts" as a position and to reconsider and expand this position to be more inclusive, expansive and relevant. The contemporary construction of the term "craft" can be defined, albeit somewhat crudely, as referring to a set of "neutral" disciplinary practices or skills in the fields of ceramics, glass, metal, textiles and wood. Contemporary craft theory, if there is such a beast, has tended to promote a belief in the sanctity of the individual maker, celebrating the uniqueness of the hand of the maker. It has also focused on a mastery of or strong relationship to materials and confirmed the craft object's status as both luxury good and as a kind of "spiritual" witness to humble labour. My aim is not necessarily to dismantle this construction of discipline and skill-based practice but simply to underline crafts' potential as a vital form of cultural production, to expand their potential as a social and cultural practice, and to mine the rich traditions of craft histories to see what they might yield in a contemporary context. In terms of contemporary craft theory, I will urge against succumbing to the increasingly dominant reactionary trends, whether in politics or in art, as well as to the nostalgia and romanticism that continues to surround so many craft practices.

I will also urge against that unique trend in craft criticism of dumbing down, of modelling the craftsperson as an "inarticulate genius." It's what I call the Forrest Gump phenomenon of craft discourse, the "idiot savant" so beloved in contemporary Hollywood film – the noble, humble craftsperson, forever consigned to wearing sackcloth and sensible shoes, incoherently mumbling, "But I like to make things." While I grant there is nothing inherently wrong with sensible shoes or even sackcloth, if one likes the look, it is a somewhat limited model.

It is also time to rethink the often uncritical valourization of the hand and the handmade, so beloved and so prevalent in contemporary craft theory and discourse. I will urge against the fetishization of labour for its own sake. It has always struck me as a supreme irony that we should fetishize the product of excessive and often highly skilled labour from an individual in the developed world and disregard similar labour originating from the developing world. There is a great discrepancy between the economic and cultural value of a basket made by a craftsperson in the West functioning within an arts marketplace and a basket from an anonymous maker in the developing world (equally labour intensive) purchased for a few dollars at a dollar store or local market, its maker visible only through its label– made in China, made in the Philippines. The hand is not the prerogative of the craftsperson, as anyone who has worked extensively with the computers can attest. A disciplinary focus can be as true for a painter, a computer animator. That is to say that it is not the domain of the craftsperson alone.

I would call for a reconsideration of the tendency in recent craft education and practice to parrot the values, forms and modes of distribution of modernist art. It has always struck me as a great irony that crafts, with their long and rich traditions of social engagement, their tactility, mobility and ability to function in so many registers of human experience, should adopt the model of the autonomous art object, that rarefied object that is attentively viewed from a safe distance, never touched let alone used, whose home is the art gallery or museum. What a loss! Craft practices, craft materials and craft histories are unique. They are ubiquitous and banal, luxurious and celebrated, denigrated and diverse – accessing a range of human experiences from the personal to the public. This is crafts' great legacy and great future. Crafts have the potential to function as a living, questioning, vital aspect of contemporary life, to articulate alternatives in an ever dwindling public sphere.

While many craftspeople will continue to follow a disciplinary path, the nineteenth-century model of the isolated artist, the genius working alone in her studio, can be expanded to create space for other more socially and politically engaged models. I would suggest the inclusion of a more expansive role for the craftsperson, a reclamation of the public space to which by their nature, history and functional tradition, crafts have such tremendous access.

When I was trying to visualize an appropriate model for an expanded view of craft theory, I first thought of a centipede, or better yet, a millipede, with many legs, suggesting many directions and many points of view, but still able to move forward together. But the centipede and the millipede are too bound by gravity and to the earth to be an adequate model for this particular moment. Instead, I would like to propose the model of an octopus (possibly one that has been cross-bred with a squid), a creature that defies gravity, whose movements circumvent conventional navigational co-ordinates and whose many tentacles allow for numerous possibilities and potentials. The model evokes the possibility of distinct, discrete or autonomous disciplinary and critical practices, but with the potential of interweaving and intertwining many strands, of joining via interlocking tentacles to other fields and disciplines such as industry, technology, ecology. While this may sound to some like an interdisciplinary model, I prefer the term "transdisciplinary," for an approach that does not dictate a blending of differences but maintains, supports and promotes distinctions, allowing for fertile crossovers and new allegiances.

Old Models/New Partnerships

Craft history provides many other models for a more active, socially engaged, transdisciplinary craft practice – the artisans' guild, the quilting bee, the sewing circle and the various utopian movements that have sprung up around craft practices. It could be argued that the medieval guild finds its counterpart in such contemporary institutions and laboratories as Xerox PARC (Palo Alto Research Center), the Fabric Workshop and Museum, the Elevated Wetlands

project and Superflex, to name a few. Although many of these organizations operate clearly within a market economy and others function as non-profit research laboratories, all work as collaborative teams to produce a blend of craft, art, industry and technology.

In Northern California, Xerox PARC, an experimental computer research lab, brings together artists and computer scientists to collaborate on projects that straddle definitions of art, science and technology. In Holland, Droog Design, an innovative design company and research lab, provides some of the most imaginative forms in contemporary design, challenging conventional notions of function and non-function, design and art, managing even to revitalize macramé, that emblem of the 1970s, to produce their dynamic knotted chair constructed of carbon and aramid fibres. The Fabric Workshop and Museum in Philadelphia, Pennsylvania, also serves as a unique transdisciplinary model. The Fabric Workshop and Museum is a not-for-profit arts centre that links artists and craftspeople with master textile printers and industry to create complex and often enormous artworks. Part research, part production and part educational facility, the Fabric Workshop and Museum connects individuals in a variety of capacities.

Another recent and noteworthy partnership between the arts and industry is the "Elevated Wetlands" project, a collaboration between Toronto artist Noel Harding and the Environment and Plastics Institute of Canada (EPIC), now the Canadian Plastics Industry Association. Harding worked with EPIC and the city of Toronto to create a series of sculptural works that encompass environmental issues, the plastics industry, art and nature in a unique way. The "Elevated Wetlands" project is a work that functions both as site-specific sculpture and as a working ecological wetland system.

Yet another environmental partnership designed in response to the needs and economic resources of a region is Superflex biogas in Africa. In this ongoing project, Danish and African engineers are developing simple, portable units called biogas, to provide sufficient gas for the cooking and light needs of an African family. The plant produces biogas from organic materials, such as human and animal waste. The biogas plant system produces three cubic metres of gas per day from the dung of two or three cattle to provide inexpensive energy.

Craft history also documents nineteenth-century sewing bees and quilting circles, communal and social models for craft practice that have been reconstituted in the twentieth century through a number of collective public projects, the best known being the "Names Quilt" which documents deaths from HIV/AIDS. Craftspeople also have the opportunity to shape how our new technologies are housed and used. After all, crafts, particularly functional crafts, are among the earliest interactive art forms.

Craftspeople have the potential to serve as what Henri Giroux in his essay on cultural workers calls "border intellectuals, to function in the space between high and popular culture, between the institution and the street,

between the public and the private."[1] They can also link practices that are transgressive and connect different forms of cultural production. Ultimately, crafts have the potential to provide us with solutions for our ordinary problems and our great ones.

Note

1. Giroux, Henri, "Borderline Artists, Cultural Workers and The Crisis of Democracy," in *The Artist in Society*, ed. Carol Becker and Anne Wiens, (Chicago: SAIC and *The New Art Examiner*), 1995

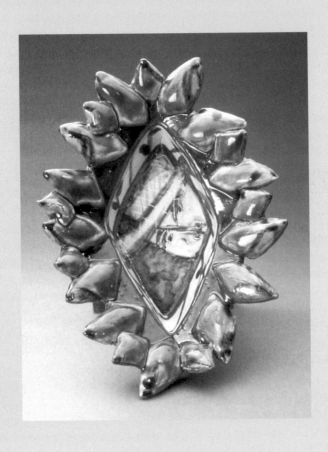

Lisa Parsons
Footed bowl, 1996
Earthenware, polychromeglaze, maiolica

Walter Ostrom is an internationally noted potter and educator. He is head of ceramics at the Nova Scotia College of Art and Design and recipient of the Chalmers Award for craft. Ostrom exhibits, lectures and conducts ceramic workshops internationally and has developed innovative institutional connections with craft programs around the world.

Several Ideas about Ceramics
Walter Ostrom

I would like to thank Jean Johnson and her committee for organizing this conference. It validates our activity. I don't know who said "art schools are the most conservative institutions in the world" but it is true. When I was asked to participate in this conference, I told Jean I was neither a craft historian nor a craft theorist but she replied that as a craft activist there must be something I could contribute. Here it is: as a junior faculty member, while lobbying our one-person art history department, I was told, "There is no such thing as craft history, there is only the history of technology." Thirty years later, there are four full-time people in art history and I am told, "as soon as we get the funding, we will hire a craft and design specialist."

There are two qualifiers here. The first is that craft faculty remain the generators, fundraisers and promoters of craft theory and history through sharing their visiting artist funding, and so forth. We also had a craft and design specialist, Alexandra Palmer, for a short period and she made a great contribution – if anything, now we know what we are missing. End of report.

Next, I asked Neil Forrest what I should talk about and he reminded me that the audience would be full of very sophisticated craft, design and art theorists and historians. Never having written a paragraph of theory, I feel that this is not the time to begin. So what I hope to do is present my own perspective, skewed and idiosyncratic as it is, and beg your indulgence. Here are some ideas that I think are important to an understanding of craft. As ideas, they are related only because they are absolutely fundamental. Please excuse my limited familiarity with other craft media as all my examples are ceramic. I am sure you can furnish appropriate examples.

A few weeks ago a very respected colleague began a slide presentation of First Nations artifacts with the disclaimer that he had not read the book from which he took the slides. At first I was shocked; however, it only took me a minute to remember my own example in this regard: this slide, taken from Peter Swann's *Monumental Art of China*, was shown in my Chinese art

history class where it served as a good example of how various styles changed over time [slide of cave, CXCVI, Tun-Huang, 8th century]. Anyway, perhaps five or six years later, I actually closely read the text only to discover the figures were unfired; I was dumbfounded. I could not imagine a piece of unfired clay lasting over a thousand years. What a wonderful example of how we see what we are trained and educated to see.

Objects Have Material and Technical Contexts

We know objects exist within social, political and cultural contexts. I think it follows that craft theory requires a solid base in craft history. I also think objects need material and technical contexts to be fully appreciated. Let me show you the kind of knowledge that accompanies the learning of a craft: [slide of open firing, twentieth-century, Kalizalia region, Algeria]. If anyone here has used this primitive technology, you will know that it requires a great deal of skill. I often wonder if there is an inverse relationship between skill and technology. This kind of knowledge is experiential and it is very important that craft disciplines keep it alive.

Technique as Process

This is an example of technique and process [slide of bowl, Nishapur, tenth-century, earthenware]. This tenth-century bowl from Nishapur is made from earthenware and covered with a wash of iron/manganese slip with white slip applied under the clear glaze. You may not realize it but you are looking at the Mona Lisa of pottery. Note that the white slip was applied with a finger; that is, it's a technique but it's also a process when you consider it was a "finger." A clearer example of process is evidenced in the dots of white slip. Note that there are some which are consistent in size and density, obviously the finger returning to reload after each dot. At least two other sets of dots diminish in size and density, appearing to have been made with a finger loaded with slip and then repeatedly applied until the slip runs out. The difference of course is time – the diminishing slip clearly reflects that slip is applied over time. It is not just technique, it is process.

Meaning Through Association

Another aspect of the kinds of meaning material can have is meaning through association. Many craft materials are of the actual world – some are similes. Glaze can be like water, as seen here in this Persian bowl [slide of bowl, Persian, thirteenth-century]. Here, glaze is a wonderful surrogate for the rich mucous covering of fish [slide of *Figures with Fish*, Chris Berti]. This glaze was developed in China over hundreds of years because its colour and texture resembled jade [slide of celadon bowl, Song Dynasty, China].

All of these examples involve direct similes with nature. However, it is also possible for a contemporary celadon bowl to carry its association with the Chinese celadon model. I think it is especially important that

contemporary craftspersons are aware of the associations with craft traditions of other times and cultures.

Pottery and Geography

The last two slides are the work of students. Lisa Parsons, who now works in Toronto, made this thrown and altered bowl, mixing technologies [slide of footed bowl, maiolica and polychrome glaze over white slip]. Historically, pottery traditions were limited geographically. A maiolica town made maiolica, a salt glaze town, salt glaze, and so on. Materials were local and technologies handed down within families and guilds. Work like Lisa's, using multiple technologies, rarely occurred.

Shelly Hedges's bowl is another example of mixed technologies; it demonstrates an appropriateness, if you will, in the selection and use of materials [slide of bowl, maiolica and alkaline blue glaze over white slip]. The alkaline blue glaze is transparent and has actual depth on the rim of the bowl. The opaque maiolica with painted symbols of underwater life lines the concavity under the watery rim.

These pots have not been made before. They can be made now because potters are trained in art schools and learn a range of materials and techniques. Soon we will drink tea from porcelain cups on raku saucers and perhaps use soup tureens with stoneware handles fired onto bone china lids.

Karli Sears
Edible Wild, 2001
Hot blown glass, Japanese paper

Dr. Alexandra Palmer is the Nora E. Vaughan fashion costume curator in the textiles and costume section of the Department of New Eastern and Asian Civilizations at the Royal Ontario Museum. She is the author of *Couture and Commerce: The Transatlantic Fashion Trade in the 1950s* (2002).

Craft Theory and Education
Dr. Alexandra Palmer

What is Craft Theory and How Do You Teach It?

I would first like to locate myself in this conference and session. In this paper I am drawing upon my own experience in the first full-time Canadian appointment as craft and design historian, in the art history department at Nova Scotia College of Art and Design (NSCAD). I held this position from January 1995 to May 1996. The brevity of the job was due neither to the lack of enthusiasm by students or staff nor the dearth of textbooks on craft theory, but rather to my being appointed as a curator in the textile department at the Royal Ontario Museum.

While I initially felt, and still do feel, that separating craft and design from art history is a mistake, there are historical reasons for this state of affairs which is well described by Paul Greenhalgh in *The Culture of Craft*.[1] However, this separation is promoted by institutional cultures, by the hierarchy of art and craft programs and by the entire social and pedagogical structure of our education system. In general, as soon as children are able to engage in creative play, their activities are formalized into "crafts" (building anything with any material) and "art" (drawing and painting). As the child matures and makes her way through the school system, even these distinctions fracture and the word "craft" tends to get lost by the wayside. As adults we are left with the impression that the applied arts as a pursuit are not as serious, rigorous or meaningful as art practice. As [M.] Shanks said in *Interpreting Objects and Collections*, "the term 'crafts'... invites caricature: comfortable middle-class people in fisherman's smocks expressing themselves in activities that were once the livelihood of the working class ... Arty pretence, complacent, conservative, safe ... It has undertones of regressive ruralism – getting back to the securities of pre-industrial village life ... Overtones of utopian nostalgia."[2]

This may seem harsh but it is clearly demonstrated by Gloria Hickey in her wonderful citation of an exchange between prospective craft consumers.

A husband and wife marvel at the articles for sale and he comments, "I just don't know where these people get the time to make them." To which his wife responds, "Well, they don't work."[3]

A student entering art school may have had a broad and varied experience with many types of art materials, and certainly with mark making, but probably few or possibly no experiences in the areas of metalwork, ceramics or glass. Textile printing, embroidery, knitting or perhaps weaving, carpentry or woodworking may be the exceptions in this list. Once in college, craft-focused students must make up for years of lost time while they wildly learn technique. Meanwhile, their art-focused counterparts are not nearly as absorbed in how to make art. For them, the importance of technique collapses as they explore ideas more fluidly and select an appropriate medium in which to articulate their concept. Craft students are very absorbed in the specificity of medium. In fact, many craft students are not competing with art students at all but learning a different set of skills.

Within craft and design education there are further divisions. Craft and design are commonly associated with the trades, and teaching has evolved in community and technical colleges, as well as art colleges. Virginia Wright has outlined the status quo in Canada.[4] In community colleges, teaching or promoting craft theory is low on the agenda and the history of materials usually constitutes the historical component. Thus, even within the field itself there is not a consensus that craft theory is a requirement. However, now that the trend in Canadian art colleges is toward a university model based on granting degrees, there is increasing pressure to situate art, craft and design practice within a more formal academic milieu. The institutionalizing of creative practice creates its own difficulties, with craft and design as the new kids on the block. Witness the recent transformation of the Ontario College of Art into the Ontario College of Art and Design, a change intended to raise its new media and industrial profile, while positioning the college for the shift from diploma to degree granting status. (Note that it is still not the Ontario College of Art, Craft and Design.) However, the academic body and funding sources still have a hard time equating traditional academic programs with studio programs. Therefore, "normal" academic components within art colleges become a focus and validation of the degree, as these are the parts that are legible and portable within a larger academic community. In this context, history and theory become even more important as requirement, proof and legitimation of art, craft and design practices. Similarly, the legitimacy of specific programs of craft and design that do not have their own designated history and theory is weakened. Fine art programs within larger universities such as York or Concordia can draw upon a full range of liberal arts classes, so there are probably similarities and differences to the art college phenomenon.

Consider this description of craft, taken from an essay by Virginia Wright [on craft education in Canada]: "Traditional and safe, homely and affirmative, craftwork is not challenging, critical, subversive avant-garde art

appearing in public gallery and discussed in the media. Art is intellectual and singular; craft is practical and everyday."[5] Yet craft students want to and are expected to exhibit in an art gallery setting, strengthening the agenda for craft theory. Students are very aware of the need to articulate and intellectualize their work and often draw upon art history and art theory to do so. At present, craft students are not as equipped to provide clever statements demonstrating the serious position of craft. Simultaneously, within craft there exists an ambiguity and conflict whereby one faction knocks at the door of fine arts and then runs away, while the other faction is preoccupied with building its own entrance. Students are stuck in the middle and have to learn to negotiate this treacherous territory.

However, the pressures to create a distinct craft theory are acute, hence this conference. In preparing for this presentation, when I was asked what I would speak about and was explaining my preamble about history, I was reminded, "You will talk about theory, won't you?" In other words there's a desire for some sort of instant theory. But you have to have a framework on which to apply theory, and this is the role of history. The two disciplines are mutually inclusive and, as John Walker has written in his book on design history, "Refusal to engage in theoretical reflections results in simplistic, crude histories which fail to do justice to the complexities of reality."[6]

Teaching the History and Theory of Craft

So, what are the models for teaching history and theory, given that we have no clear direction in Canada? Certainly the emergence of design history studies in England provides a formalized approach evolving from students within art and craft colleges asking for object histories not undertaken in traditional art history. However, I also suggest that the practical aspect of teaching craft and design history in a North American context is different than in Europe. North American students are not that conversant with European history, architecture, decorative arts or design. They have not lived in a material continuum of history, and their first-hand experience generally reaches back only to the early nineteenth century. Most bring very little knowledge of history to the class-room. Therefore, by and large, the post-secondary professor starts from zero.

Having said all this you may well ask, now what? At NSCAD, my mandate was to teach craft and design history and theory to students in the two disciplines. In fact I was serving several masters: the art history depart-ment, the craft department (comprised of ceramics, metalwork and textiles) and the design department, which is a two-dimensional communications program with no three-dimensional design. The assumption was that the fine art students were already served by the established art history courses.

But whose history and theory should one teach? Is it the history of materials and technology (textiles, metal and glass)? Each medium has its own history. While these histories are already accessible via museums and books and can be explored independently by students during studio time and

on their own, I should add that these histories do appeal to the students. However, this is an unfashionable academic approach and, practically speaking, would use up my class time, leaving none for the required survey courses or much anticipated theory. A better solution was to move away from a strict university teaching model with clearly divided studio and academic class time, in favour of incorporating aspects of medium-based history into a studio class. This required collaboration between the academic and the studio professors. The approach worked well for a silkscreening studio where I came in for an hour each week and discussed the historical making, use and meaning of printed textiles, moving beyond a chronological history of printed textile technology. I can also add that the inference from the liberal arts side was that this was deemed a "lightweight" approach. One wonders if this was because the strategy was geared to craft, or because it eroded the distinctions between studio and academic practice?

Building a Foundation for Theory
My larger aim was to open the craft students up to the history of their practice in the broadest sense, thereby setting the foundation from which to construct and embrace theory and make it relevant to their practice. But as June Freeman has written in her essay on intellectuals in the contemporary craftworld, "At the moment ... studies of the crafts lack any theorized approach to the analysis of material culture. They thus add little to our understanding of the social role of the different arts."[7] Ten years later this is still the case. However, I suggest teaching a history that employs design, culture and social history in addition to marketing, consumption and gender studies and incorporates theoretical models – in short, a material history approach to craft and design is appropriate. This is not new or radical. By taking such an approach one begins to do what in 1989 John Walker called "examining not only what design [and, I add, craft] does to people, but what people do with craft and design."[8] Without a solid base of history, craft students are set adrift. They know how to make teapots, cups and bowls but in most cases have little understanding of the social or cultural use or meaning of their own production. By teaching the historical and changing meaning of objects, one begins to understand what Daniel Miller has recently called the "mattering." He writes, "I would argue that the term 'matter' tends to point in rather a different direction from terms such as 'importance' or 'significance.'"[9] Miller calls for the use of ethnography to map objects from conception to consumption, though he concludes that "material culture studies ... remains eclectic in its methods. Approaches from history, archaeology, geography, design and literature are all equally acceptable contributions ... We as academics can strive for understanding and empathy through the study of what people do with objects because it is the way the people we study create a world of practice."[10] By locating craft practice in a historical and sociocultural continuum the students felt they had a position within the strong "art" ethos of the college.

Material Culture Rules

Despite the fact that there is no nice compact textbook called *The History and Theory of Craft* (if there was I would have been the first to use it), there is a real demand for a separate pedagogy for craft and design history – one that is apart from yet intersects with art history. However, while craft and design deal with materials, the canon of art history is still focused on the so-called high arts, while the crafts are more located in our material and social world. This is why I believe that a material culture approach is so appropriate, and there is an increasingly rich academic pool of writings and ideas to draw from that moves across formal disciplines. Articles such as John Styles's "Manufacturing, Consumption and Design in Eighteenth-Century England"[11] help students to begin to understand craft beyond the iconic object and locate it in a historical and social framework that includes production, marketing and consumption. Canadian content can be inserted, such as Elizabeth Collard's work on Wedgwood or Oscar Wilde's Halifax lectures. Also the history of women and textiles in art colleges influenced by the Arts and Crafts movement could be directly related to a student's own college history and present situation.[12] Once students have a background in the history of their profession they can participate in key debates. For example, they could discuss the position of the unique versus the mass-produced, historically and in the post-industrial age, and draw from writing ranging from the big guns like Jean Baudrillard and Pierre Bourdieu to such writings as Paul Greenhalgh's chapter "The Prefabricated and the Mass-produced" to ideas about contemporary craft as fetish.[13]

Adventures in Craft History

One class for senior students I developed that began to incorporate history and theory was called Decoration and the Home. We addressed historical issues of domesticity and the attendant trappings from dinner services, glass, linens, invitations, dress and etiquette. It easily bridged the art, craft and design factions. While another course, Craft Discourse, was directly aimed at the craft students, it was poorly attended as they did not really want to delve into the unknown area of theory and it had not been made a requirement (which I think it would have become had I had stayed on longer). Topics for this class were fairly basic but were generated to provoke reading and debate. They included:

What is craft?
Approaches to the meaning and writing about craft
How to research craft
The historical position of western craft
Production: isolation or Utopia?
The institutional history of craft – where is its place?
Field trip to the Nova Scotia Centre for Crafts and Design (The director, Chris Tyler, discussed its history, its strategies and its role as an economic development centre and partner with provincial tourism.)

Women's role in craft (We looked at a range of issues from women's roles in the pottery industry to caregivers/craftspeople working from home.) Folk art – is it craft? (Though only three students registered for this, four more did audit the class.)

One student wrote on the course evaluation: "It's so important to talk about craft; I just wish the fine art students took it so that we don't have to keep educating them."

Required Reading

To conclude, I strongly urge that craft and design history and theory be inserted into the liberal arts requirements from the start of a post-secondary education. This component ought to be required of all students – art, craft and design – in the same way they are already required to take art history surveys. This curriculum modification would create a fertile ground and, hopefully, a muddying of boundaries as the ideas and histories are not mutually exclusive. Thus, by the final years of college the students would be aware and versed enough in history to really apply and debate theoretical concepts. Again this seems obvious, but in my experience it doesn't happen. Adding mandatory courses in the history and theory of craft and design would also require dealing with the contentious issues of increasing students' academic load or decreasing studio time. Nevertheless, it is only by implementing academic rigour in the craft syllabus that students will be able to articulate and expound upon theoretical craft issues. Then they can debunk the soppy, romantic images of craftspeople and seriously discuss things such as Morrisian theory. Then they can select, reject or find new applications, just as the American soap salesman Elbert Hubbard did with his Roycrofters workshop in New York State, where behind the utopian facade he had his workers punch a time clock hidden behind a curtain. Without the basics I don't see how craftspeople can create and contextualize a distinct theory of craft. Let's start with the basics and move toward the future.

Notes

1. Paul Greenhalgh, "The History of Craft," in *The Culture of Craft*, ed. Peter Dormer, (Manchester: Manchester University Press, 1997), 20–52
2. M. Shanks, "Craft," in *Interpreting Objects and Collections*, ed. Susan M. Pearce, (London and New York: Routledge, 1994), p. 107
3. As quoted by Gloria Hickey in "Craft Within a Consuming Society," in *The Culture of Craft*, p. 87
4. Virginia Wright, "Craft Education in Canada: A History of Confusion," in *Making and Metaphor: A Discussion of Meaning in Contemporary Craft*, ed. Gloria A Hickey (Hull, Quebec: Canadian Museum of Civilization with the Institute for Contemporary Canadian Craft, 1994) pp. 79–85
5. Ibid.
6. John A. Walker, *Design History and the History of Design* (London: Pluto Press, 1990), p. 10
7. June Freeman, "The Discovery of the Commonplace or Establishment of an Elect: Intellectuals in the Contemporary Craft World," *Journal of Design History*, vol. 2, 2 & 3 (1989), p. 62

8. John A. Walker, op. cit., p. 183

9. Daniel Miller, "Why Some Things Matter," in *Material Cultures: Why Some Things Matter*, ed. Daniel Miller, (London and Chicago: University of Chicago Press, 1998), p. 11

10. Ibid., p. 19

11. John Styles, "Manufacturing, Consumption and Design in Eighteenth-Century England," in *Consumption and the World of Goods*, eds. John Brauer and Roy Porter, (London: Routledge, 1993), pp. 527-554

12. Elizabeth Collard, *Nineteenth-Century Pottery and Porcelain in Canada*, (Kingston and Montreal: McGill-Queen's University Press, 1984), pp. 77–88; Kevin O'Brien, Oscar Wilde in *Canada, an Apostle for the Arts*, (Toronto: Personal Library, 1982), pp. 165–181

13. Jean Baudrillard, "The End of Production," in *Revenge of the Crystal: Selected Writings on the Modern Object and its Destiny, 1968–1983*, eds. and trans. Paul Foss and Julian Pefanis, (London, Concord: Pluto Press, 1990), pp. 99–127. Paul Greenhalgh, *Ephemeral Vistas: The Expositions Universelles, Great Exhibition and World's Fairs, 1851–1939*, (Manchester: Manchester University Press, 1988), pp. 142–172

Peter Fleming
Garland Entrance Table, 2002
Afromosia, limestone and cast bronze
85 x 40 x 75 cm

Peter Fleming is a furniture designer and maker and part-time faculty member at Sheridan College School of Crafts and Design (SOCAD), Oakville, Ontario. He produces client-commissioned and self-generated furniture and related objects primarily in wood. Fleming is chair of the board of directors of the Wood Studio, a non-profit woodworking co-operative in downtown Toronto. He has received numerous awards including the Prix Saidye Bronfman Award (2001).

Wood Practice
Peter Fleming

Theory suggests the absolute. I must begin therefore with defining terms: The *Oxford English Dictionary* (which we trot out when unsure) defines theory as a supposition explaining something based on principles independent of the phenomena being explained, or the opposite of hypothesis. I find that I like the relative fluidity of hypothesis, defined as a starting point for investigation; a groundless assumption or supposition made as a basis for reasoning. And then there is the thesaurus installed in my computer which lists theory and hypothesis as synonyms. So this is where I start? Do I trust the page or the program?

I would like to put forth the argument that theory in my craft is directly related to practice and, in fact, is indistinguishable from it. I work almost exclusively on commissions, and therefore I am more couturier than artist. I design my pieces of furniture in response to a client's brief, tailor it, as it were, to their need and desires, while maintaining my own aesthetic agenda. This concept of patronage governs my work and consequently affects my interaction with students and the necessary translations of experience into anecdote that teaching requires of me.

I teach one day a week at Sheridan College in the furniture program of the School of Crafts and Design. I am at the college six hours per day, twenty-eight days per year, or if one supposes a sixty-hour week, with four weeks of vacation, this represents .058% of my professional time. It seems such an inconsequential number, relative to the portion of my entire life I spend sleeping (29%) or even eating (.125%). Yet the time spent at school is the most gratifying and gruelling part of my professional life.

It is here that I have to articulate in a clear and concise manner what makes my work function. And by extension help students to understand how they can approach their work in a confident and effective manner. I do this quite literally, by hand. I demonstrate techniques and talk about their significance in the overall process of furniture making. As time goes by I am less

satisfied with lecturing without a prop, something which demonstrates the actuality of what I am describing. Without it, eyelids droop, stimulants are required, I hear my voice drone on, and I know that once again I have become disassociated from my task. Several years ago a student whom I had taught drafting for over a year asked me if I made furniture also, in addition to teaching?

I was floored. Furniture is so much a part of my identity that I assumed that it showed on my skin, like a gaudy tattoo. But then I realized that the root of the confusion was multiple. The concept of a practitioner teaching part-time is perhaps foreign to someone who is a year out of high school and used to thinking of teaching itself as a profession. Yet I feel that it is just this professional involvement in the heartbreak and exultation of making that ensures my currency as a teacher. I don't think that I had succeeded in describing the link between what I was teaching and why I was teaching it.

Tools of the Trade

What are the tools that students need to achieve this connection between the what and the why? Curiosity, first and foremost. An inquiring mind questions assumptions that seem static. An ability to communicate ideas; words are good, drawings are better, and we need to be proficient in both. And of course a smattering of cynicism to keep it all in perspective.

Somewhere lower down on the list comes technical knowledge; while it is an easy thing to teach, technique is often the aspect of craft that eclipses all others in the minds of the aspiring maker and client alike. This skill comes with practice, and practice is what craft is all about. I do some things so frequently that they become as natural as breathing. I have picked up a hand plane and used it sometimes thirty times a day, every day, for close to twenty years. I know what it can do. I don't question it. In my head the form exists as an ideal, often somewhat vague; the hand plane helps me make it real. When I pick up a rough-sawn board I instinctively know by the way it balances in my hand which way it will warp, how hard the wood will be to work and how best to cut it to achieve my goal and avoid waste or physical risk. These are perceptions that I experience with my entire body and are impossible to verbally transfer to someone else.

I remember an address given in 1984 by Adam Smith, a "fallen" knife-maker redeemed as a computer minister. In the talk, which was reprinted in *Ontario Craft* magazine shortly thereafter under the title "Making the Case for Craft," Smith spoke of the inherent conundrum of machines made by other machines. He described a milling machine that produces flat surfaces in metal, accurate to a thousandth of an inch. The sliding surfaces of the milling machine, or "ways" as they are called, are made on a surface grinder much more precise than the milling machine, accurate to approximately one ten-thousandth of an inch. The ways of the surface grinder are made on another surface grinder, and so on, like a Russian doll. But the problem is that surface grinders can't produce accurate enough ways for other surface grinders.

Which means that after they are ground, someone with a great deal of skill and experience scrapes the ways by hand.

In the same address Smith speaks of the antiquated machine shop that he knew of which had a Spar Aerospace truck parked in front of it for the entire time the Canadarm was being built. Thank you, Adam; these stories always give me hope, even though Spar Aerospace just divested itself of the Canadarm to concentrate on the cleaning and servicing of airplanes (hardly a romantic craft ideal).

Computer-Assisted Design

Other perceived threats to craft as we know it come from computer-controlled machines that can cut and shape complex forms in just about any material. Colleagues routinely use the services of small-run production houses to fabricate repetitive furniture parts with computerized routers, freeing up time that can be better spent on the things that these half-million-dollar machines are far too crude to do. The precision of this machinery is seductive, and has spawned an embryonic change in the way work is carried out in our shop. The rough form of the backrest of the dining chairs I am working on currently will most likely be made by a CNC machine.

Prototyping tools used by industrial designers currently include machines that can produce mathematically accurate models of objects which only exist on the computer. A mobile table sits within a tank of resin that is scanned by a computer-controlled laser, instantly solidifying a thin layer. The table moves down a notch, and the laser scans again, in a minutely different pattern. The process repeats, and pretty soon we have a perfect prototype sitting on the table. Another tool based on a similar concept uses thin sheets of self-adhesive card stock which are cut to profile by a computer-controlled knife. The layers are built up on top of each other and, once again, the perfect prototype is revealed. These techniques, however, are nothing more than the logical extension of the process by which wooden boats have been made for centuries. A series of cross-sections through the width of the boat are joined together to form one of the most beautiful and logical forms made by man.

Drawing by Hand

Most of my students harbour an initial reluctance to draw; in their impatience to get to the end product, they can lose sight of the process of making, which is probably the real reason why they chose a craft-based program to begin with. If we merely wanted to own the objects which we so thoroughly desire and imagine, we would have gotten a real job with a good wage, and gone out and bought them. I know that that is what my bank manager would rather have me do. But instead, we gradually find ourselves captivated by the act of making, generating an object that has never existed before.

Early on, however, the student sees the finished object as the goal, not the means to an end which is the mastery of the process of designing and making the product. And so, instead of freehand drawing, students will ask

me what computer drawing program they should use to present their ideas, as yet unformed. I can't fault them in this. Computers have become such an intrinsic part of my work that I was totally lost when a few weeks ago I had mine in for servicing.

Like many, I now communicate via computer, draft on it, write letters, use it for a variety of other time-consuming processes that I once did manually. I also spend a hell of a lot more time in my office than ever before. This is progress; it means that I can drink while I work, unlike when I am using the tablesaw.

The same students who are reluctant to draw view new technologies in an almost romantic Elysian light; they do not yet realize that they are merely tools, and rather crude ones at that, compared to the huge range of possibilities that a pencil can offer. The level of finish is so homogeneous on drawings produced by the computer that it becomes untrustworthy, just as the standard effective fundraising letter now appears to be written by hand, a handcrafted object set in opposition to the slickness and deadening lack of individuality of a form letter.

I work occasionally with an architecture firm in Toronto that is deservedly well-known for its residential renovations. They send me drawings of projects that they are working on which are, seemingly, painstakingly hand-drawn, with a barely perceptible and charming quaver to the line quality. I've never spoken to the principal of the firm about why they do this, but I can take a guess. If you work in a world of certainties, as architects must, you run the risk of scaring off a lot of people. The firm wants the client to feel that there is some level of flux in the concept described, and that it is all very personal and private, like two lovers exchanging letters. All the drawings, of course, are accurately drafted on the computer and then manually redrawn on tracing paper and reproduced. Someone recently told me that there is now an overlay program for CAD that will do the same thing, redraw over the existing drawing with a layer that is warm, fuzzy and serves to insinuate the personal into a process that is formal and precise.

Which brings me back to "hypothesis," with its inherent flexibility. Hypothesis, I feel, is a most appropriate description of transferring the making experience into something that can be talked about. When making, the ground shifts a bit with each discovery in relating one form to another, or seeing how a material can be transformed or pressed into a service previously unconsidered. This is indeed the starting point for an investigation, a groundless assumption made as a basis for reasoning, where the results have yet to be tabulated into theory.

From the viewpoint of the maker, conjecture is the cornerstone of the process of commissioning work. Don't ever tell the clients this – they need more reassurance than that. Commissions are interpersonal projects which stand apart from the traditional solitary act of the maker. There is a curious split there between the public act of consultation and salesmanship and the

private act of designing and making. I have had difficulty at times, feeling that by doing one well, I am neglecting or even negating the other.

Exercises in Relating

So it goes like this: I get a phone call from someone who wants me to make a piece of furniture. Generally they have seen other work of mine, or I have been recommended by another client, so thankfully they have a bit of an idea of what they are getting into. I visit their home, gather information on the way they live, make assumptions about their needs and tastes, and leave with my head full of another person's life. Once this information has steeped like strong tea, I develop a piece that advances my own aesthetic while serving the client's needs – in essence generating a body of work on the bankroll of others.

This is not so much a collaborative process; rather it is a problem-solving exercise that exists on many levels. I must juggle both the functional and the intangible aspects of a client's demands. I relate their expectations to my previous experience in similar projects and attempt to bring them together with my own agenda.

One requirement of the dining suite I am working on is that the table must seat sixteen. At twenty-four inches per place setting, that requires a sixteen-foot table, seven chairs down each side and one at each end. The client is concerned: maybe that is too big; we want enough space, not to feel cramped, but not too big. We want something classic, traditional but not too formal, contemporary, with some edge to it, but not out of control. Something rich, perhaps a dark wood, with a figure, but not dark-dark, more like a middling dark.

What they never tell me, but what is often in the subtext of this conversation is that they want to seat sixteen and impress fifteen. The most intangible aspects of the brief are these hidden desires: their motivation for commissioning the piece, their associations of luxury, what they hated about going to their grandparents for Friday or Sunday dinner, or what they wanted their life to be, enacted painstakingly through the objects that they use. That is what I have to figure out for myself, and hope that I get it right early on so that I can retain their trust and not go bankrupt.

Self-Generated Works

Speculation, however, puts the maker in double jeopardy. One becomes client and maker when doing work for exhibition. What alarms me is that I can't blame failed self-generated works on the dubious taste of a client. Here are two more definitions for the verb "to speculate": to pursue an inquiry, form a theory or conjectural opinion; to make an investment, engage in commercial operation that involves the risk of loss.

Exhibitions provide a rare opportunity for the commissioned craftsperson to reorient the aesthetic compass. The work I do for exhibition is generally a financial writeoff; it can't hope to pay for itself in the way that

Article continues on page 119

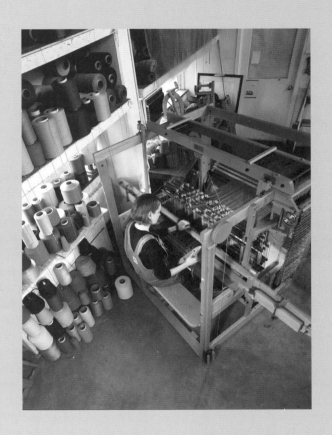

Loom, Material Art and Design Fibre Studio
Photo: Lorraine Parrow

Ron Shuebrook is an educator, administrator, art writer and artist who is currently president of the Ontario College of Art & Design. A painter, he exhibits his work internationally. Shuebrook's reviews and essays have been published in art and craft periodicals and exhibition catalogues. He is the immediate past president of the Universities Art Association of Canada and has served on the executive of the Royal Canadian Academy of the Arts.

Collective Memory, Craft History and Theory: A Canadian Perspective
Ron Shuebrook

From a post-colonial, postmodern, pluralistic Canadian perspective, it has become increasingly commonplace to be skeptical about singular accounts of any subject as being definitive, fundamental or essential. We are wary of the received opinions of others and now speak of our histories, our theories, our cultures, our contingencies. Each version of knowledge and experience is recognized as a proposition that has been shaped by particular perceptions, ideologies and circumstances. Such a proposition is necessarily understood as merely a partial glimpse, generally awaiting supplementary information and subsequent fresh interpretation. In a world of continual becoming, many of us in the post-secondary educational community seek to nurture a more inclusive awareness in ourselves, in our institutions, and in our society. We strive to develop our understandings of the values and expectations that have unconsciously guided individual behaviour and the structures, policies and practices of our institutions. In the spirit of open inquiry, we are led to interrogate the foundations of our beliefs and aspirations in order to negotiate appropriate and necessary change. Moreover, it is absolutely crucial for those of us involved with professional education in art, craft and design to investigate the underlying factors and assumptions that have, indeed, marginalized our creative disciplines within the education system, particularly in the university sector.

Implicit in the focus of this symposium is the urgent need to locate craft practices and related historical and theoretical scholarship within the academy. We require little reminding that the university is considered by many to be the primary guardian of this society's collective memory. Assumptions within our universities about the status of the crafts as a subject worthy of disinterested, serious scholarship have given rise to the issues we are addressing throughout this symposium.

The Educational Context

Considering the limited to non-existent instruction in craft practices, history and theory in the broader university context, it is not surprising that these practices are undervalued and have diminished status within Canadian society as a whole. A cursory review of undergraduate courses in several of the leading art history programs in Canada – at the University of Toronto, University of British Columbia and York University – reveals no coursework in craft history and theory. Only Concordia University lists solid offerings in the history of ceramics, history of textiles and related seminars devoted to historical and contemporary aspects of "craft" theory and history. However, the actual word "craft" is not used to categorize these practices. One wonders if there is any commitment at all to stimulating scholarship or having any substantial collective memory about craft on the part of each of these universities. There is no evidence for optimism on this question.

Having noted the apparent invisibility of craft in the context of traditional university-based scholarship in this country, we are compelled to direct our modest inquiry to the craft studio programs in the four Canadian art and design colleges.[1] One must be hopeful that these institutions believe in the necessity of a practitioner being knowledgeable about the history and theory of the discipline to which they may devote their lives. Acknowledging the hierarchies that dominate the research and scholarly agenda of most universities, the professional art and design colleges, at least, promise to be a site for craft discourse.

A quick survey of the calendars of the Canadian art and design colleges show that each of the schools is committed to providing sound historical and theoretical underpinnings for the practice of art and, to a lesser extent, design for their students. Academic offerings that are particularly pertinent to an understanding of craft history are, even in this educational sector, decidedly problematic. The fact is that the word "crafts" is used only in the calendar of the Nova Scotia College of Art and Design (NSCAD) to refer to those fields of practice associated with the materials of ceramic, fibre/textiles, jewellery and metals, and so on. As is widely known, NSCAD's substantial reputation has been based on the fact that it has an educational objective of requiring its students in every discipline to confront the historical and theoretical circumstances of their practices. It is my understanding that it is now also possible to pursue a minor in art history at NSCAD. By implication, this program at least has the potential to stimulate much-needed craft scholarship in this country. It is also important to note that it is the only college that unabashedly describes a substantial group of courses in its curriculum as being "craft history." Such a declaration is, indeed, encouraging.

On the other hand, Emily Carr Institute of Art and Design (ECIAD), Alberta College of Art and Design (ACAD) and the Ontario College of Art and Design (OCAD) never refer in their publications to any field which they teach as being among the "crafts." ECIAD, in fact, seems to teach only ceramics among the traditional craft disciplines and situates it within its

school of visual arts. Admirably, it also offers a course in the history of ceramic art as well as an informed range of art historical and theoretical courses in Western and non-Western cultures.

ACAD locates the traditional craft disciplines in their fine art division and, yet, provides a full range of practices devoted to the materials: ceramics, glass, jewellery and metals, and textiles. Admirably, each of these specific disciplines has an apparent historical and theoretical course devoted to those aspects of the field such as Textile Practice: A Cultural Survey, Ceramics Practice: A Cultural Survey, and so on. Other design history courses and non-Western art history courses, according to their college calendar, acknowledge aspects of craft practices, including references to furniture.

The Ontario College of Art and Design also avoids any current reference to crafts and chooses rather to describe such traditional fields under the collective title of Material Art and Design or MAAD. This terminology does clearly suggest some grappling with the implications of language while complicating the possibilities for pertinent historical and theoretical discourse and curriculum in this field at the college. MAAD is administratively grouped with the faculty of design and includes ceramics, metalsmithing and jewellery, and fibre. Currently, there are survey courses in the history of material art and design as well as a visiting lecturer series which helps practitioners become familiar with the "chronological progression and the stylistic appearances of ceramics, metalwork and textiles." In addition, indigenous traditions in the material arts in Europe, North America and Asia are considered in selected courses. Coupled with a wide range of art and design history courses, as well as offerings in cultural studies, OCAD does, in fact, provide potentially rich opportunities for students to acquire a substantial knowledge of craft history and related areas of study.

As far as I have been able to discover, no formal courses fully devoted to craft theory currently exist in these professional art colleges. However, given my personal knowledge of the many astute individuals who teach the practice of these disciplines, I am well aware that theoretical issues are integrated by many faculty into the studio courses themselves. Nevertheless, systematic, closely reasoned consideration of theoretical issues essential to the practice and interpretation of the disciplines does not currently seem to be an integrated part of formal studies in craft.

One, of course, notes this state of affairs with some sense of dismay, but, at the same time, with an intense awareness of the wonderful, transforming work to be done. Seeing so many people taking part in this symposium, it is intensely obvious that we must take immediate steps in our own institutions, in our own communities, to get on with the work in craft history and theory that is demanding to be done. All of us in this room simply need to take up the challenge. In my view, any genuine attempts will improve on the current pitiful quantity of Canadian craft history. Lack of formal credentials in art and design history need not intimidate anyone. If the craft community continues to wait for others to document their passions, the only thing likely to be achieved

is a state of anxiety. On the other hand, if we allow the experience of this event to move us, surely we will undertake the tasks before us.

Traditional Philosophical Assumptions

Before I bring my remarks to a provisional pause, I want to speculate briefly about some of the possible reasons why the universities have demonstrated so little interest in craft practice, history or theory. The lack of status of crafts at the university level may also have discouraged craft scholarship in the professional art and design colleges as well. As is well known, many writers trace our current assumptions about the intellectual foundations of education to the Greek philosophers, including Plato and Aristotle. Plato, on one hand, banished the artist, and on the other hand made distinctions between the artist and the craftsperson, adding significantly to the confusion. He claimed that the artist's achievements stem essentially from inspiration rather than reason, while the craftsperson's accomplishments depend on his knowledge and skill. The noted philosopher and art critic Arthur C. Danto traces one of the earliest distinctions made between art and craft to Plato's dialogue "Ion," in which Socrates explains:

"Ion has a great gift as a rhapsode and can move men's minds, but, that he lacks knowledge and so depends upon inspiration. The craftsman is the Socratic paradigm of him who has knowledge. So Ion cannot teach, cannot pass on to others what he has but inherited, craftsmen again being models of the teacher. Socrates's carpenters and cobblers get to be the Master in our tradition while Ion, possessed and driven by forces outside and higher than himself, gets to be the genius."[2]

This hierarchy places the artist in a superior position to the craftsperson, and, by inference, establishes a ranking for the fields themselves. Furthermore, the concept of liberal arts, the cornerstone of the university, was first delineated by Aristotle as those "studies for the education of a freeman,"[3] which are undertaken for their intrinsic value in the development of reason and moral grounding in the pursuit of truth. According to Aristotle, the liberal arts are not mechanical and should never restrict the mind through specialization.[4] While they are certainly not utilitarian in an obvious sense, he concludes that they are, indeed, broadly influential in educating human beings for a democratic society.

Within the English tradition of education, which serves as significant precedent for the Canadian university system, Cardinal Newman, rector of the Catholic University of Ireland in the 1850s, outlined his concepts of liberal education in 1873 in *The Idea of a University*. Declaring the university's function to be intellectual culture, Newman said: "Intellect must have an excellence of its own ... the word 'educate' would not be used of intellectual culture, as it is used, had not the intellect had an end of its own; that had it not such an end, there would be no meaning in calling certain intellectual exercises 'liberal' in contrast with 'useful', as is commonly done."[5]

During the last century in North America, universities have certainly had no difficulty accommodating numerous utilitarian fields within their purview, particularly where lucrative endowments might be concerned. As we all know, schools of business, engineering, medicine and dentistry are now prominent within the Canadian university. The visual arts and, to a lesser extent, design have found their way into the university as well. In Ontario alone, there are approximately thirteen or fourteen undergraduate degree programs in the visual arts, three design degrees and, perhaps, two joint degree programs in which craft practice is a major area of study. There is, however, not one program in which craft history or theory are featured as a major. I can only wonder where we will find our own craft historians and theoreticians when no one is educating them? The only potential sources for scholars and theoreticians of craft are craftspeople themselves and curious connoisseurs. My impression is that the few books and catalogues that have been published about Canadian crafts have largely been written by people from those categories.

Concluding Remarks

Setting aside the intellectual habits and inclinations that descend from ancient Greek thought, there is a less elevated reason for the resistance to the study of the histories and theories of craft, and to a lesser degree, visual art within the university. A case could be made that most of Canada's academics and intellectuals are one generation away from the working class and are resistant to the hard, physical work that may have been their parents' lot. Despite liberal claims to the contrary, there's a tendency among the intelligentsia to suspect any cultural practice that assumes that the physical body is an irrefutable component of existence. In this light, the university favours the immaterial over that which is most physically present, relegating the material-based practices of the crafts to a very low status within Canadian society. Can it be any wonder that relatively few have taken on the responsibilities of craft scholarship? The task is now left to those courageous and able people who care about the heritage of their own fields, or to those individuals who have simply been surprised by their own depth of feeling and engagement with craft objects. Those of us who have been transformed by the production or transfixed by the presence of a craft object that is whole, inevitable and potent with implied meaning will feel the need to bear witness to our craft heritage. Our small but resilient group must take on the challenge. I suspect that resources will be found as we convey our experiences of grace and caring manifest in objects that have been built by conscious choice with conviction and, often, love.

Article continues on page 120

Gary S. Griffin
Hollyhock Doors, 1994
Wrought steel, paint over steel
200 x 150 x 7.5 cm

Gary Griffin is a practicing metalsmith and professor at Cranbrook Academy of Art. He has exhibited in the US, South America, Japan and Europe. Griffin has focused upon utilitarian fixtures for residences, such as doors, tables and lighting fixtures and is noted for his gates, for which he has received several major commissions.

Material
Gary Griffin

Ideas and things are not the same. What one imagines or conceives of is different from that which one makes. If one looks for meaning in the maker's intentions, where is the idea located? Is it in the object? Is it in the written and spoken language that surrounds the object – or both?

Often, contemporary craft discourse emphasizes self-expression and conceptually constructed images. Rarely, if ever, does one find a discussion of how the medium supports these claims and rarely does one find affirmation that materiality and physicality have instrumentality of any kind. What happens to a group of people who make things and then speak only of the idea of things?

Cartesian dualism made a very significant point: What one imagines or conceives is different from that which one makes. Ideas and things exist and function in distinct, discernible ways, and while the difference between thing and idea may be clear to producers, the language used to describe objects seldom addresses either the distinctions between or the co-dependency of the physical and the non-physical. When makers choose to adapt their critical paradigm to include an affirmation of the usefulness and meanings found in the physical, they make it possible to more clearly name and appreciate all of the different elements (content, material, process and so on) that contribute to the significance of their objects. In so doing, they make available to themselves an expanded, more complex method of evaluating their work.

The Alchemy of Iron

I'm here to talk about things, and material in particular. In this limited time, I want to share some thoughts and observations about material. To do that I will focus on one material, iron. Iron is an ambivalent material. Historically, metalworkers have produced objects that contribute not only to the celebration of civilization, but have simultaneously contributed to its destruction. Blacksmiths have been responsible for forging ritual ornaments, surgical

tools, the tools of agriculture and the tools of war. In both traditional and modern culture, iron has often occupied an ambiguous place, tinged with wonder but also awe and fear.

The Delphic oracle saw iron as the instrument of destruction as well as that of civilization. The Koran echoes this view. In parts of West Africa, tribal attitudes toward iron were ambiguous. For this reason, the men who worked the iron were caught in a paradoxical position: while their bold and meritorious services were indispensable to the community, they were relegated to a position outside the society. They were held in a disdain that seemed grounded more in fear and awe than scorn. This is due in part to the historic sorcery that was necessary to smelt iron.

Specifically, the Mande people assigned magical powers to iron, and as late as 1970, as a newly smelted two-hundred-pound piece of iron was dragged steaming from the furnace and blacksmiths poured water over the metal to cool it, the townswomen would come forward, lifting their skirts to better absorb the vapours. The population considered the material to be charged with the regenerative power of the smelting enterprise. Smelting rose to this position not only because of the sorcery associated with the process but also because the population understood that the ingot anticipates its subsequent form as a sword or plowshare.

Medieval alchemy may seem far removed from our reality, but its influence is all around us. Consider the symbols we use for female and male. They have their roots as alchemical symbols and, in fact, the use of these familiar symbols in relation to metals predates their more familiar use as gender signifiers. In alchemy, what we recognize as the symbol for male has its origins in alchemy as the sign for both iron and the planet Mars. It came to represent "male" because of the similarities between the perceived physical properties of iron and the perceived attributes of men, including strength, hardness, sturdiness and endurance.

The Ecology of Iron

The iron mines in the upper peninsula of Michigan played out in the late 1970s. Many of those mines were in Iron County, Michigan, and within its boundaries are towns named Hematite, Bessemer, Iron Mountain, Iron River, Anvil. The highways and roads often take the names of mines, such as Sunday Lake Mine Road and Bristol Mine Road. Plymouth Mine Road goes to the former Plymouth Open Pit, which is now Plymouth Open Pit Lake. In Crystal Falls, Michigan, the county seat of Iron County, the local newspaper is called the Diamond Drill. Most of the road beds in that part of the country are a kind of rust colour, the result of years of mining hematite ore. We all know hematite, that wonderful polished grey bead that is common in jewellery. The earth of the Great Lakes region is primarily iron, and hematite is the most common of the iron ores.

These samples [I'm holding] are hematite. The large rock is in the rough and the smaller piece is formed and polished for jewellery applications.

For a moment, think of this material as locale. I think it was Edward Abbey who said, "Naming is knowing." These pieces of rock are a place, they are locale. They are not only a physical place on earth, but also material invested with human endeavour. The mines of Iron County have been closed, but the ore displaced from the Lake Superior region continues to be mined today. The mines have been relocated to your neighbourhood. Scrap, the corroding shards and hulks of mechanical civilization, takes the form of metal sawdust and borings from small factories, odds and ends from blacksmiths and sheet metal workers, old farm tools, iron bedsteads, gates, fencing, washers and dryers. In a curious way, you are in Iron County; you are a part of a mining system.

Of all scrap, the greatest in quantity is scrap steel. Today, scrap steel constitutes more than sixty percent of the entire raw material requirements of the steel industry. Scrap would seem to be the dominant raw material, not only of the present, but of the future. Today, the mines of scrap are the esti mated one billion tons of finished steel, someday to be scrapped, that are on top of the earth. This is twenty-five percent greater than the estimated tonnage of refineable iron under the earth that can be commercially mined under present conditions.

The Garden Project

If material is locale, then it may also be understood as being local. Material is from somewhere, somewhere specific, and it can be the physical presence of the history of people and place. In 1995, fifty artists were invited to submit proposals for interventions into the collection at the Detroit Institute of Arts. My proposal focused on Diego Rivera's fresco entitled *Detroit Industry*. This proposal was awarded the space of the Rivera Court. [Shows slides of Rivera murals and the Garden Project]. The following is the statement I wrote for this project which is entitled "The Garden"[1]:

"The *Detroit Industry* frescoes celebrate 1930s Detroit, the city of the industry of modernism, the city of the five-dollar day. They also represent a story of material, specifically the story of steel. From the upper portions of the north and south walls, the minerals associated with steel making are repre- sented with their associated geologies. These minerals are transformed to become the machines, the conveyors, the wrenches portrayed in the murals. I am interested in steel and the associated processes that transformed the earth of the Lake Superior region into engine blocks, transmissions and the machines of manufacturing.

"The counties of the Lake Superior region that were once rich with iron ore are now welfare counties. The mines are mostly closed except for those that have been converted to tourist sites. The city of Detroit acknowledges its past from an equally humiliated position. Today, the city of Detroit has become the mine. Annually, thousands of tons of scrap iron and steel are recy- cled from the aging buildings, junk cars and non-competitive machinery to enter the fire of basic oxygen furnaces. Today, sixty percent of every piece of

Article continues on page 121

Critical
Writing

Kai Chan
Portrait of a Young Man, 1999
Dogwood, bamboo, garlic stem, cinnamon
127 x 41 x 43 cm
Photo: Isaac Applebaum

Janet Koplos is a senior editor at *Art in America* magazine in New York. She has been writing about crafts since 1976, when she was editor of *Craft Connection*, the publication of the Minnesota Crafts Council. She has since written more than 1,500 reviews and articles in scores of magazines and newspapers, including *American Craft, Fiberarts, Metalsmith, Glass and Crafts*. She is the author of *Contemporary Japanese Sculpture* (1991) and is currently working on a book about Dutch contemporary art.

What's Crafts Criticism Anyway?
Janet Koplos

Philosophical Muddle

I sometimes have an uneasy feeling that the fascination with the quantity and quality of writing about crafts is a clinical case of displacement. Criticism has become a convenient hole in which to shovel all the controversy, all the quality issues, all the identity crises surrounding the uncertain position of contemporary crafts, which have lost their functional purposes and so retain only decorative and symbolic ones. These essential issues should be faced in every class taught and in every object made. Sometimes they are, but often these "critical issues" get postponed or, more precisely, they get hidden under the easier-to-talk-about subject of "what's wrong with crafts criticism?" I'd suggest that the character of the criticism reflects the character of the field. Two major considerations are the tendency not to think things through and to borrow ideas from elsewhere. In some times and places, function, decoration and symbolism have been a seamless unity. But in our time, and in the West, the symbolic is sharply separated from the other two; the symbolic can be art, and it's presumed to be pure or ideal or intellectual, while function and decoration are popular and commercial and base. Of course, that division in itself doesn't make sense, because the creators of symbolic objects have to make a living too, and art has always been available through commission or purchase. People get paid for making even religious art. Even those people who claim to be uninfluenced by sales secretly hope that someone, someday, will recognize their value – in money. It's all commercial.

Besides that, if both the functional and the decorative have the same liability of being commercial, why has function been driven out of the academy in the case of clay but not in the case of jewellery? Why has the decorative sometimes been considered to have an intellectual underpinning while function has not? This muddle tells us right from the first moment that we are not dealing with a rational situation. And the more we talk, the more convoluted it gets.

Engagement with the Real

The works that are lumped together under the heading of crafts hardly relate to each other except on the basis of specific material and attitude toward material. There is a little bit of sense in that, because works made of fibre, clay, metal and glass rarely – I might venture to say never – lose sight of what they're made of. By that I mean that unlike painting or sculpture, the medium never becomes invisible. It's not just a means to make some particular point, but is always part of the point. Of course, there is some painting like this, too – work that loves its own smeary substance, that's about its colours and textures and light-capturing translucency, all that. But there's also plenty of painting that's not – that's about a social scene, or a mood, or a political issue, or about the conventions of art, or about change, or alienation, or a zillion other subjects, in which paint plays only the service role of communicating the issue. You can have a whole discussion about the meaning of the work without even mentioning its physical conditions. And painting is the most conservative of art mediums now – contemporary art can be made of anything; artists may work in many mediums or hire someone to execute an idea in a medium they can't handle themselves. Meaning is often independent of means.

I don't think anyone in the crafts fields wants to make work like that. I have the impression that people get into fibre or clay or whatever either because they try it accidentally and have an unexplainable and irresistible experience like falling in love, or because they see someone do it and discover how sensual or physically focused or excitingly dramatic it can be, and they're hooked. They go on in that medium not because they have ideas or emotions raging to get out of them but because they want to touch the material – that specific substance with its tactile and olfactory and auditory and visual qualities.

In crafts the medium never becomes invisible. It's not just a means to make some particular point, but is always part of the point.

This is certainly not a new idea on my part; it's an accusation that has been made against crafts for a long time. I think there is truth in it: it describes a basic condition of the field that affects every other aspect. The primariness of material justifies specialized teaching in academic departments such as ceramics or fibre, and it in part explains why crafts tend to be shown together in specialized galleries. And (I finally get to the point) it goes a long way toward explaining the ghettoization of crafts criticism. Crafts is a specialized subject. A handful of ceramic artists show in mainstream New York galleries, but generally crafts are shown separately, so that you have to already be interested and seek these craft venues out in order to see the work. There may be a little more mixing outside New York, but in general the most prestigious avant-garde galleries are the ones least likely to show what we call crafts – although they may show work by their regular artists that

incorporates glass or clay or textiles. (I suspect that such work is the least discussed part of these artists' bodies of work because of the obstacle of specialized language and because painting or sculpture critics don't know how to consider the craft materials.) The separateness of crafts venues makes a problem when it comes to crafts being accessible for art critics and art audiences and increasing their knowledge. It's not necessarily a problem for all audiences, however, and it reinforces the sense of community in crafts by making that audience easier to know because it's smaller.

I assert that there's nothing wrong with being devoted to a medium and having the medium shape the work. That's not inherently a weakness; in fact, I can see a philosophical and psychological strength in engagement with a single real substance. This intimacy and depth of knowledge in a way is like a marriage. It seems to me that this kind of bond is wonderful for the maker and can be vicariously experienced by the viewer if the intensity of the feeling is visually expressed in the work. And I should think that would be a greater value as an alternative in a virtual age in which our hands are often empty. If I extend this idea of devotion to the extreme, I could say that, in comparison, the kind of contemporary art that focuses on ideas and uses whatever materials are necessary is like an egotist talking about himself through a succession of one-night stands. But I'm exaggerating. The issue is really what can be understood of this exploration of the capabilities for expression in any medium – paint or needlepoint or whatever.

Justified Hesitation

I have heard art critics say they can't write about crafts because they don't know the terminology and they don't know the history. I think this hesitation is justified: a conscientious critic does not wish to write in ignorance, and there are specialized vocabularies for these materials and unquestionably there are long histories and current contexts out of which the work is produced. Only rarely does a craft work capture critics and provoke them to learn what needs to be known. Critics are always too busy. But they are also professionally susceptible to having all their arguments swept away by powerfully persuasive artworks. That can happen in crafts.

Some craft publications have tried to win over art critics and increase the number of people addressing crafts by inviting art critics to write for them; this has been a two-edged sword. It does accomplish its aim, at times, of introducing a fresh perspective and serious consideration. But it's easy for the consideration to be badly skewed by the critic's lack of knowledge.

In the best case, you get a writer like Arthur Danto, an emeritus professor of philosophy, who sees the big picture of issues such as function, gender roles, rule-breaking, inversions or distortions of reality, and adds a level of discussion not present in ordinary crafts criticism. On a slightly less exalted level, you may simply get better writing, because the field of art criticism is older and broader and more competitive than crafts criticism, so talent develops. But at the worst you get cases of garbled or pedantic or fatuous or

constipatedly theoretical art criticism applied to crafts. Crafts critics and editors seem to suffer as much from lack of confidence as many makers do, so they're sometimes too willing to swallow anything that comes from the fine-arts field. I would say that what's dreadful in art writing is just as dreadful in crafts writing. In both arenas some people assume that big words equate with importance, obscurity is a sign of profundity, and difficulty is a measure of worth. But this sort of difficulty is often the result of critics (or academics) obfuscating because they are not really sure of what they're saying, so the best way to protect themselves is with a smokescreen. It's an "emperor's new clothes" situation. Someone should say the stuff is balderdash – but who does? Who will?

Giving reasons for opinions about art is harder still in the case of crafts, because there is not even a consensus about when criticism is appropriate.

Art today is expected to have a meaning that can be articulated verbally as well as visually. Sometimes the artist doesn't do that so well, and it's a critic who fleshes out a concept and furnishes the artist with a vocabulary to use in discussing the work. In the art world there have been cases of critics – Clement Greenberg, for example – making studio visits and telling artists how they should change their work, what they should be doing. Or there are critics who see everything in terms of their preconceived interests, such as Donald Kuspit, who reviews everything psychoanalytically. The crafts world fortunately does not seem to generate critics with such high-powered agendas of their own, perhaps because people so full of themselves wouldn't want to bother with a low-status field for their efforts. Unfortunately, Kuspit has been one of the critics invited to write about crafts ...

There is, however, a tendency in both the arts and crafts fields to admire such forceful arguing, such assured opinionatedness. This is an attitude that in the art world has led to criticism being considered an art form in itself, with critics responsible only to their own personal expressive and creative imperatives. I think that if critics want to make art they should be artists, with all the risks that involves. I have no sympathy with this attitude toward criticism. I believe that criticism is a service profession, an aid to understanding. It is essentially parasitic because it can't exist without the art "host" to grow upon. Criticism should be helpful, not confusing or intimidating.

I like something that the art critic Carter Ratcliff wrote recently: "Art discourse is designed to convert sensuous experience into manageable thought." That's a very nice way of putting it. The critic speaks in words about a nonverbal expressive form. The eighteenth-century philosopher David Hume said a true critic, or Ideal Observer, has "strong sense, united to delicate sentiment, improved by practice, perfected by comparison, and cleared of all prejudice." He said that the public should recognize and evaluate art by following such an observer's guidance. I would say that the best critics observe

closely, think carefully, draw fresh personal conclusions, and express them well. That's all there is to it. But you may notice that I've named processes and said nothing about specific content. Well, of course, the problem is what you're looking at and the point of observing and thinking about it. These good critical practices have to be applied to the specific work at hand. All criticism is based on expectations which critics implicitly or explicitly name as they discuss the work. No art critic writes about everything; all survey the field and make choices about what seems to them to be meaningful and important. They are human and can be swayed by peer pressure and can make mistakes and later change their minds.

I suppose you could say in a general sense that "criticism" is a thoughtful skepticism about anything in the world. You can have a baby-care critic, and a garden critic, and a bus-driving critic, a window-display critic. It's possible to critically approach any experience. A professional critic falls somewhere between being a sympathetic listener and a back-seat driver, but we hope closer to the first. Basically, criticism is an outside opinion of a performance or product, with the opinion explained – in speech or, more often, in writing. The philosopher Albert Tsugawa has noted that the essential critical activity is not having an opinion, because everyone has opinions, but giving reasons for the opinion. The reasons, presented in a public forum, are what enable us to share in or respond to the critic's thoughts, and provoke our own thinking and therefore affect our response to the work.

Giving Reasons

Giving reasons for opinions about art is hard, because the subject is inherently multilevel and ambiguous and because, since the collapse of classical academies, there is no formula or standard to measure things against. Also, no conclusion can ever be final since context and comparisons change with every single new work that's made and every day that passes. Giving reasons shows us a pattern or model of thought, which we can apply or reject as we come to our own conclusions. Good criticism helps us to think. If we regularly read certain critics and come to trust their judgment, criticism may be a time saver, a shortcut to knowing which works are worth bothering with. The philosopher Bernard Harrison asserts that the essential function of critics is simply to indicate which artworks repay attention.

Giving reasons is harder still in the case of crafts, because there is not even a consensus about when criticism is appropriate. Art criticism developed as a specialized discussion about the meanings of paintings or sculptures – along with evaluations of how the meaning is communicated (such as what visual devices or conventions are employed and what individual skills of hand or mind are demonstrated). Obviously, painting is not a useful object that you can eat off or wear, so function is irrelevant to its criticism. Therefore, criticism is a borrowed or appropriated activity that is not a perfect fit to the crafts. It is not useful in talking about what was a major aspect of the field, function. I probably don't need to point out that the result of this mis-fit has

been the shrinkage of functional work over the last couple of decades. Crafts are now taught in art schools, so they exist in the context of art criticism; thus there is pressure to apply it, and applying it changes the field.

The work that most seriously wants and needs and deserves the intense scrutiny of art criticism will probably find a way into the pages of art magazines.

Sometimes there's an assumption, I think, that the application of art criticism to crafts will result in the crafts being considered art. But this is a very precarious path. Most likely it results in crafts just being considered second-rate art. Besides, if you try to make yourself into someone else you'll probably succeed only in losing track of who you are. If you want to do what someone else is doing, you'll inevitably remain a step behind because you can only copy what's been done, you can't get ahead of it. If crafts has its own character, why shouldn't it have its own form of response, perhaps not even "criticism" at all? If crafts meets the expectations of art criticism, is it still crafts? If it's not, why are we here together under this label?

I've said before and I will say forever that criticism is just one form of writing, it is not suitable for everything, and what can't be written about critically is not automatically of lesser worth. But I think I'm crying in the wilderness when I say this. Nowadays, to adapt Walter Pater, it seems that all crafts aspire to the condition of art. What we're here for – to discuss the nature or lament the specifics of criticism – is a very "art" thing to do. We're at a conference in which theory and criticism are presumed to be important enough to bring us all together to talk and to ponder. We're addressing subjects common to art criticism and academic activity, modelled on these practices that are not native to crafts but are deemed important now. Again, how do we adapt them to reflect the specifics of this field, instead of what we've been doing: adapting the field to the expectations of criticism?

What Craftspeople Want
We might consider what is it that craftspeople want when they say they want criticism, or better criticism. I think the desire to be reviewed is just a plea for attention and response. I think what is sought is a response specifically to the work, but it occurs to me that craft objects are not immaculate conceptions that exist in isolation. I digress here: recently I was thinking about why so much art writing is boring, and why I have to sometimes force myself to read even the excellent writing about art in the *New York Times*, whereas it's easier to read about movies or music or literature. It crossed my mind that writing about all the other art forms incorporates people into it. Novels and movies are stories about people doing things. Music nearly always involves a performer, so there's someone to see while you're listening, in most cases. Music can be every bit as abstract as visual art, but a show of visual art lacks direct personal participation – except to the degree that we recognize the

gestural residue of the maker in the surface character of the artwork. Recognizing that is quite a demanding intellectual task, which is probably why art seems elite, now that artists aren't in guilds and practicing in neighbourhoods, so we don't know them. And maybe that's why so many artists write literally on their works nowadays, because words, and especially handwriting, are a more familiar and graspable personal residue. But I suppose this discussion is outside the scope of this lecture and this conference.

What are the impediments to the kind of criticism that craftspeople desire – bearing in mind that criticism is not a pure form and can have multiple uses? Let's assume they're looking for an intellectual criticism that explains the work to interested readers (but don't forget it's also an endorsement of sorts that dealers can use to promote and to help sales).

All craft doesn't have to aspire to the condition of art. Maybe we could talk about it in design terms, and give some credit back to functional work.

If I wanted to be mean, I'd say that the main limitation to serious criticism is the niceness factor. What I refer to is the kindness and sense of community that pretty much characterize the crafts. Even when there's a little backbiting, it's almost never in public, and that's the social pattern in small towns, too. The crafts world is a small town, a community, although it's geographically dispersed. So critics don't tear into the work they're reviewing, and the part of the crafts world that might benefit from that kind of stimulation loses out. Even the publications that most closely model themselves on art magazines are soft. If a textile magazine wants a review, the editor has to find a writer who knows something about textiles, and that often means another textile artist. Or else it's a friend of the artist – who would most often talk with the artist in order to know what to say in the "review."

Journalistic Objectivity

That's not a review. It doesn't meet the basic standard of journalistic objectivity, or the critical standard of independence. The softness occurs because writers don't want to be too hard on someone they're going to run into again in this "small town." And writers don't want to alienate editors, because there aren't that many publications so there are few other options for the writer. So they try to be pleasant and mannerly. What results is a "conversation." It involves communication of information and accomplishes a certain PR function, even if it's not really criticism.

Similarly, editors aren't tough on the work of the writers that they're editing. Why would that be? Well, the pay is poor; maybe they try to make up for it with a modicum of congeniality. Maybe they don't know any better? Maybe they have consciously decided on this tone? Regardless, what's published is a high percentage of pablum – nourishing to some degree but pretty bland. Editors don't push, they don't ask the critics to think harder

about this or that statement, they don't ask for a more felt poetic translation from the visual of the work to the verbal of the review or essay. We're all so congenial in this business. We're all so polite.

If I were looking for a "better" crafts criticism, I would simply want better writing, showing thought and care.

But even if that results in a form of writing that doesn't match the competitive and challenging nature of art criticism, is that so bad? The real question this panel might address is not what can be done, but does it matter? The work that most seriously wants and needs and deserves the intense scrutiny of art criticism will probably find a way into the pages of art magazines. But a lot of people who want a critical response make work that doesn't quite have the program or the originality that would win praise in art magazines. For this work, isn't existing crafts writing fine? Aren't the number and the tone of present publications satisfactory? Why shouldn't we go on with reviews as they are now, nicely describing composition, surface texture and colour, scale, imagery, associations, what the artist has done before and says about this work, and maybe even something about technique? Aren't those all interesting things to discuss? Don't they all have relevance to how we appreciate the object? And is this not the field's own reasonable response to its needs? All craft doesn't have to aspire to the condition of art. Maybe we could talk about it in design terms, and give some credit back to functional work. Maybe we should accept, as a kind of folk wisdom, the balance that has evolved?

Some Changes
However, I confess that I personally would like to see some changes. The argument I've been making through most of this talk suggests that what exists must be sufficient, since, if there were a demand for something else, someone would meet it. Nevertheless, when I think over the pattern of English-language publications I'm familiar with (I don't know them all), it seems to me that there have been periods of great intelligence in the writing and editing of several of them, which is usually due to the work of a single person (among these would be Rose Slivka, Martina Margetts, Gerry Williams and Michael McTwigan – all of them active in the field, more than just editorial worker-bees). It's possible that a good editor arises in response to a fertile period of work, but it's also possible that the effect goes in the opposite direction: maybe a good editor provokes thoughtful writing which encourages good work. It might also be equally back and forth. Each good situation has come to an end – for various reasons, but the one that seems most fixable is financial: a publication needs not just an editor with vision and the ability to draw the best work out of writers but also a publisher with the organizational and sales skills to generate ad income to support the publication. Craft editors and critics should not be

engaged in the charitable donation of their skills. You don't nurture capable professionals that way.

When I read crafts magazines, often I itch to edit – just to assure basic communication. I don't think anyone can be a good critic without being a good writer, and great writing can sweep us along even when we don't agree with the opinion – an experience I have had with the conservative critic Hilton Kramer. If I were looking for a "better" crafts criticism, I would not be looking for theorizing borrowed from literature or other fields. I would be wishing not for more jargon but for the right ordinary language to do the trick. I would not be hoping for critical infallibility. I would simply want better writing, showing thought and care. I would wish for an intense concentration on the work, on what's there, the actual stuff and what it makes you think and how it makes you feel. I would also wish to encourage writing on the widest range of work, from traditional crafts in industry to contemporary design to traditional functional objects to the art crafts that predominate now – with tone and vocabulary of the writing adapted to the subject. I would also want the writing to have a personal voice, and to sometimes be excited, and exciting, when that's appropriate. I would wish for the writing to be less self-conscious, less ruled by inherited suppositions of what criticism should be and what sort of language it should use, less worried about what peers and competitors will think. The best writing would be like the best work, enlightening and from the heart.

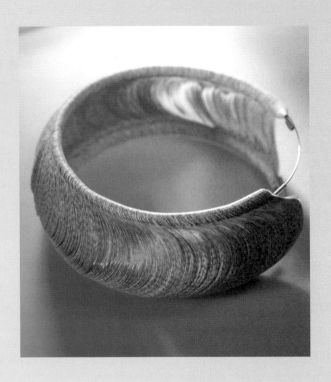

Janna Syvänoja
Necklace, 2000
Recycled paper, steel
14.5 x 5 cm diameter
Photo: Jukka Vazanew

Courtesy: Charon Kransen

Blake Gopnik holds a Ph.D. in art history from Oxford University. Formerly editor of *Insite* magazine on architecture and design, he was also visual arts editor, and then visual arts critic, of the *Globe and Mail* newspaper. In January, 2001 he was appointed chief art critic of the *Washington Post*.

Adorn Yourself with Attitude:
Blister packs, fishing weights, toe splints as jewellery? Try it on.
Blake Gopnik

To the woodworkers in the audience, I would like to make a plea for a better crutch design. [Brandishing a crutch] Everyone who has ever had crutches has had to tape foam rubber to the top, because the people who design these things haven't figured out yet that they actually kill you if they don't have foam rubber taped to the top. Actually, I don't need them at all, I just brought them for the sympathy vote, because after reading the abstracts of my fellow panelists, I got so terrified I thought that this would help me. I was going to bring a white cane and sunglasses, but I thought that might be going too far.

There is something about the popular medium of newspaper journalism that raises issues in craft criticism that don't come up when you're writing for specialized magazines like *American Ceramics* magazine or even for a design magazine like *Azure*. There is something special about speaking to a broad audience, to people who are not expert in the arts, to lawyers, doctors and chiropodists ... and there is also something special about talking about the crafts as a non-member of the craft community.

I'd like to believe that not being a member of the craft community, while it has its perils, actually does engender a certain independence such as Janet Koplos was advocating earlier today; that said, I am aware of the strengths and shortcomings of both the visual arts and craft discourses.

The discourse of crafts is well-placed, however, to address some of the central issues in postmodern conditions. It considers objects within the context of use and social relations. It challenges the regimes of value imposed on different media by virtue of their positions within class, gender and cultural relations, and maintains a direct engagement with the body through its continued respect for both traditions of handmaking (the body of

the maker), and traditions of utility, the body of the user. Even the term "the user" conveys a wealth of potential discourses beyond those implied by "the viewer."

I'd like to think that there's something good about trying to come at things from the outside, which is what I do in this review entitled "Adorn Yourself with Attitude: Blister packs, fishing weights, toe splints as jewellery? Try it on," which appeared in the *Globe and Mail*, July 22, 1998[1]:

The greatest joy, and challenge, of an art critic's job is to dig up potent, ground-breaking contemporary art from the corners where it lies hidden. For though there may be lots of good work out there, in the art world's current lull, not much of it pushes hot, new buttons. That's why I was so excited when, on a recent wander through the Montreal Museum of Decorative Arts, five modest display cases caught my eye and made my heart beat faster. So what if they were full of jewellery?

Painting and sculpture, and even relative newcomers such as installation and video art, have had their day in the sun, and seem to be taking an aesthetic siesta. So maybe there's a little window of opportunity for some of the sleepy "minor" arts to wake up and get things moving.

In those five vitrines, a small travelling show called *European Jewelry: A Matter of Materials*, curated by New Yorker Charon Kransen, presents objects that profoundly recast the old and well-established traditions of jewellery-making. (Traditions, in fact, that long predate the stuff we've canonized as fine art.) Objects that break the rules of those traditions with gay abandon. Objects that make their audience rethink the stuff we use to decorate our bodies. What could be better contemporary art than that? And you can wear it, too. (Some Torontonians may even have had a chance to try it on when the show made a stop at dealer Suzann Greenaway's Prime Gallery in the spring.)

As the exhibition's title hints, some of what's going on here is just about giving silver, gold and diamonds the boot, and at long last leaving other materials a chance to strut their stuff. If, in the fine arts, the battle to rank the worth of artists' brains over the worth of the stuff they work has long since been won, jewellers still have to fight that good fight – and right now in Montreal, a few of them seem to be winning a skirmish.

The medium of choice for Janna Syvänoja, from Finland, is paper torn from an old phone book. Swiss artist Verena Sieber Fuchs prefers discarded pharmaceutical blister packs. Others use lead fishing weights, or medical prosthetics, or rubber cut from inner tubes. Netherlander Ted Noten's palette includes a dead mouse encased in plastic. And, as usual in art, the radical change in materials makes for a radical change in how artists think about their shaping. Syvänoja

doesn't make a Cartier tiara from her white pages; she makes gorgeously gracile twisting forms that take advantage of the slippery sloping of piled paper, and that would be unachievable in any other medium. Yellow pill packages have a gorgeously prickly, sparkling look when mounded together into Sieber Fuchs's giant ruffs and collars. (She uses the sprockets cut off of film stock, piled high and thick, to a similarly crisp effect.) And as can be imagined, when Netherlands-based Iris Eichenberg assembles flesh-toned toe splints and other pink medical rubberware into boppy, bumpy jewellery, it doesn't look much like anything from Tiffany's.

But there's often more to this jewellery than just what it looks like. Unlike traditional goldsmithery, which doesn't talk about much beyond the wealth of its owner, many of the pieces in Montreal have little nuggets of meaning and reference buried in their beauty, just like much of the best of contemporary art. Some, like Syvänoja's paper necklaces, or the neo-Elizabethan collars in black-rubber lacework by Thea Tolsma, simply proclaim the underrated beauties of their humble materials. German-born Stephan Seyffert pushes the same issues further, taking famously precious stuff – glowing pearls, blood-red coral, quartz crystals – and then blowing it up in goofy rubber to make pop facsimiles of the traditional *objets de vertu*. And the blister packs of a Sieber Fuchs necklace called *Toxicomanie* (French for drug addiction) or those medical splints turned Eichenberg brooches have an edge to them determined to shift our thinking about jewellery out of the vaults of the wealthy and into Needle Park and the hospital ward.

Dutch fashion designer Alet Pilon, on the other hand, doesn't let us forget the tastes and traditions of the filthy rich, even as she perverts them. Remember the mink wraps once favoured by society matrons, all rodent heads and varmint tails? Pilon does them in fake fur, but fits them out with more unusual body parts. For elegant evening functions, how about a collar in deep and silky-piled black, trimmed with a neatly polished cow hoof at each end? Or for daytime use – perhaps that Chanel suit could use a bit of jazz around the neckline – the fuzzy, funny yellow of another rappy wrap is given a sober trim ... of pheasant skulls, all dark and shiny and picked clean of flesh. More wearable art for those who find a diamond-studded bracelet, like a landscape on the wall, a bit too safe for comfort.

Note
1. Reprinted with kind permission of the *Globe and Mail*

Toronto Dominion Centre

Courtesy: Cadillac Fairview Corporation

Mark Kingwell is a critic and cultural theorist based at the University of Toronto, where he is associ-
ate professor of philosophy and a senior fellow of Massey College. In addition to a number of schol-
arly works, he publishes in many newspapers and magazines, including the *National Post*, where he
is a columnist, and *Harper's*, where he is a contributing editor. His latest book is called *The World
We Want: Virtue, Vice and the Good Citizen* (2000).

On Style
Mark Kingwell

Recently, at long last, I achieved a dubious personal goal, one of those mark-
ers of urban sophistication that I learned to covet not through experience or
direct association but via the altogether more powerful, and more ideal,
realm of the movies.[1] A bartender in a downtown hotel lounge knows my
"usual" drink.

Yes, it's true. I walk into the bar, which shall remain nameless to avoid
any hint of impropriety, and without a word he reaches for the bottle of
Bombay Sapphire gin, chunky and blue and multifaceted like its namesake.
Soon an icy martini of unwise proportion is standing before me, a triumph of
minimalist elegance in lines if not in size: the perfect stemmed triangle of the
glass, the dewy condensation on the clear cone of liquid, the curled lemon
peel's sole playful colour note.[2] I almost hate to drink it. Almost.

I don't remember when I first started drinking martinis – judgmental
people would say this is no accident – but I do know, as anyone today must,
that the recent vogue for cocktails has a whiff of retro about it. I like martinis,
but I can't but be aware that they are, like so many cultural markers of style
today, overdetermined. Or rather, overdetermined and undetermined at once.
On the one hand, they have multiple untrustworthy nostalgic associations, the
sort of faux Rat Pack posturing that, unless ironically undercut, is the fast
road to deep uncoolness. On the other hand, all this ironic undercutting that
nimbler hipsters go in for is a kind of style nihilism, cutting culture loose
from its moorings, making every marker – every song or suit, every grace
note or building facade – a free-floating signifier without history or context.

Take a single but telling example: The Cherry Poppin' Daddies, a young
California swing band in the vanguard of the much-touted big band revival, just
released an album called *Zoot Suit Riot*. How many people have cultural memo-
ries long enough to read that title not as some kind of fashion-dance imperative
but as an allusion to racial hostility and immigration politics in 1940s America?
Zoot suits, favoured by Latinos, featured billowing high-waisted pegged

trousers and exaggeratedly long jackets; they used a lot of material at a time when material was scarce. Crew-cut Los Angeles white kids took that as an invitation to mix it up; hence the "zoot suit" riots.

So what does wearing a zoot suit, or listening to swing, mean now, when Mexican-American immigration issues are more tempestuous than ever? Is this blithe freedom from political consciousness really acceptable? Is a suit ever just a suit? (I won't say anything about the band's name, with its vulgar reference to deflowering virgins.)

It's probably a condition of living in these liminal, late-century times that we can't seem to transcend these oppositions of form and matter. And there are others. Materialism is all the rage, yet a desire for spirituality is stealing across the cultural soul. Technological fetishism has never been more aggressive or more widespread, yet the most discussed new consumer durables are those, like the VW Beetle or Macintosh iMac, that are technically ordinary but wrapped in a "comfortable" bubble-contour aesthetic apparently borrowed from the toy box.

There is of course no simple relationship, still less any necessary opposition, between style and substance, just as there is no necessary conflict between beauty and utility.[3] (The faster car is almost always the more lovely car, and the workaday hammer or knife is, indeed, beautiful.) How we shape the things and experiences of everyday in turn shapes us – and speaks volumes about who we are or, more important, wish to be. As style, from the Latin *stylus*, was originally a particular manner of wielding a pen, a way of choosing within the available store of calligraphic and linguistic options, so style is now the attempt to express personality within the grammar of life.

That's why the simplest and best definition of style is the title of that classic of post-war sociology, Erving Goffman's *The Presentation of Self in Everyday Life*. Style is the projection of personality upon the canvas of existence, the attempt to impose character on the otherwise undifferentiated – or merely banal – surfaces of eating, drinking, dressing, dancing, perambulating and dwelling. With the possible exception of how one wears one's hair, all of these style-projects involve, even demand, association with the world of design: the need to be fashioned in particular ways, usually with the help of artisans of some aesthetic accomplishment.[4]

But this is perhaps just to state the obvious. The interesting question is: what is our style today? In terms of design, what will the tag "1990s-style" connote a few decades from now?

I sometimes think the only valid generalization to be made about the 1990s is that, for unsurprising reasons, they have been a time of cultural processing, a restless retrofitting of design notes – in music, in clothing, in architecture – borrowed willy-nilly from the vast lumber-room of twentieth-century invention. Borrowed and, mostly, denatured thereby. Thus, for example, formerly revolutionary bebop is reduced to restaurant background music, aural wallpaper for people eating high-piled pan-Asian confections in a room by some tony architecture or design firm.

This recycling is unsurprising because it is typical of a milieu on the cusp of something. Whatever you want to say about the much-palavered millennium – and I've said my fair share – it does loom large as a horizon of meaning. We can't get on with things, we can't fashion ourselves anew, until we pass through that arbitrary doorway, hoping all the while that our computers will still function, and therefore begin the compelling business of deciding what it will mean to be twenty-first-century people.

Hence the relentless always-already quality of so much design and style today. It is nothing more than the necessary knuckle-cracking, the nervous arpeggios before the real performance. If we are being charitable we might call it postmodern, all this cheerful mixing and matching, but maybe it is really no more than the final spin-down of modernism itself, a going-nowhere form of textbook review. There is a genuine 1990s style, in other words, something we might agree to call, with only a little irony, Late Capitalist Pan-Modernism.[5] It embraces the contradictions of hard and soft, material and spiritual, and renders them intelligible – even if it doesn't, finally, resolve them. Above all, it says something important about our current obsessions and blind spots.

With the celebrated exception of a Frank Gehry triumph, say the Bilbao Museum, what confronts us is an kind of undifferentiated internationalism, the design fallout of market globalization.

I'm writing this in Berlin where one of the biggest development projects in European history is remodelling the area around Potsdamer Platz, formerly a slab of the Berlin Wall, into what omnipresent posters call *die Stadt von morgen* ("the city of tomorrow"). The development, a sky-lifted new downtown, is aggressively, almost parodically modern, modelled more on a nightmare vision borrowed from Godard's *Alphaville* than on anything organic to the site: like all "modern" development plans, it is more about what it keeps out and erases than what it inscribes. Construction cranes stretch as far as the eye can see. Cantilevered slabs of steel tubing and massive, hard-edged panes of glass are everywhere. First cousin to concrete brutalism, this emptily "progressive" architectural style now dominates cities from Brussels to Birmingham to Beijing. Meanwhile, the Euro highways are filled with what Douglas Coupland once called "bubble-butt cars,"[6] bright little blobs of plastic and metal of which the overhyped Beetle is just the latest example. Few have the noh-mask grille and Noddy-and-Bigears charm of the Mazda Miata, a pioneering example; most are just wimpy little squirt-mobiles with sewing-machine engines and hopeful "personalizing" decals and sunscreens, the automotive equivalent of homey screen-savers or mouse decorations on your home computer. These attempts to individuate – just as with the celebrated exception of a Frank Gehry triumph, say the Bilbao Museum – only underscore the fundamental sameness of this "Modern" look across Europe and the world. Style is always about choosing within available limits, but what confronts us is a kind of undifferentiated internationalism,

the design fallout of market globalization. Even the tanklike Mercedes sedans of recent years have been pushed aside by the softer contours of the yummy-looking late-model cars on display outside my hotel room. The room itself is an odd collision of Olde Worlde wood panelling and hunting prints with a bathroom that belongs on board Captain Picard's Enterprise D: the squat suction-effect toilet, the cylindrical airlock-tube shower stall with its transparent, rubber-sealed doors.[7] It's all enough to make you long for the shark fins and battleship surface area of a '57 Chevy, the overt militarism of a Ford Bronco or HumVee.

What we see, despite some domed rearguard actions, is a generalized modern style that, divorced from particular context, creates its own global context. This modernism is arguably also postmodern, not in transcending master narratives but rather in inscribing its nostalgias and selective eclecticism within the same old overarching aspirations of Progress, Freedom and Commerce. The vertiginous modernist look of such science-fiction films as *Brazil, Gattaca* or *Dark City*, say, where fountain pens, pneumatic tubes, Avanti sports cars and hats for men lie alongside featureless mega-buildings and spaceships, is what we seem to be heading toward – only without their warnings of a totalitarianism within.

Likewise in the home, where a sleek pan-modernism of objects from upscale urban design stores – alien-invader juicers from Italy, neon-green salt cellars from Sweden – cohabit, apparently without rancour, rooms decorated in the Shaker boxes and overstuffed couches of Martha Stewart's notional New England. Newly hip magazines like *Wallpaper*, really just catalogues by other means, celebrate this new urban self-presentation with unabashed self-indulgence combined with a willful ignorance of the fierce, ongoing struggles for everyday identity that actually dominate urban life.

In fact, this allegedly forward-looking Internationalism for the brand-conscious, jet-set young – Absolut vodka crantinis consumed to the sound of remastered Astrud Gilberto while dressed in a Canali four-button suit – is really no more than a form of lifestyle pornography. Not satisfied with mere conspicuous consumption, this relentless fetishism of style isolates its objects in a loving light whose sheer gorgeousness brooks no refusal. You look because, as with a car accident or erotic movie caught on TV, you just can't help it. And then, presumably, desire takes hold of you: I want those shoes! I can't live without that coffee table!

The pressing political question here no longer concerns the cultural dangers of mass mechanical reproduction, a topic which preoccupied critical theorists of modernism proper like Walter Benjamin (though these dangers remain, and are still sometimes thematized in the art world and elsewhere).[8] It is, rather, getting *anyone at all* to see that the ambiguous triumphalism of this new modernism is, like jazz gone uptown or R&B rendered by Pat Boone, a drastic diminution of style's political possibilities.

It is often said that the problem with Marx's critique of capitalism is that it's too forgiving: it doesn't see how good market liberalism is at

accommodating and assimilating resistance. (A fact which numerous recent youth-directed ads, with their mock-ironic anticonsumer messages, amply demonstrate.) The same might be said, and for similar reasons, of modernism – at least when it declines to the status of a mere style. The *illusions* of freedom and sophistication are now exported everywhere, often with great aplomb, superb taste and impressive commercial success. But style no longer seems much to serve its only true purpose, which is to carry forth the uniquely human project of individuating ourselves, of making a claim for personal identity.[9]

And that is deeply sad. We must never mistake the stylish ghosts of modern individuality – however nicely backlit, however well-dressed – for genuine emancipation.

Editor's Note: This article was first published in *Azure* magazine (Nov./Dec. 1998) pp. 41–3.

Notes

1. I was thinking of those Nick-and-Nora *Thin Man* movies, with William Powell and Myrna Loy, where they line up their martinis in orderly rows for maximally efficient consumption.

2. Russell Smith, *Noise* (Toronto: Porcupine's Quill, 1998): "'Another beautiful mad girl,' said James to no one. He swirled the martini in his oversized glass. The gin on his lips tasted of headache. 'I love martini glasses,' he announced."

3. The modern idea is (as Kant said) that beauty must be "disinterested" to be valid; that in turn suggests that utility is the value of all other things – a sharp departure from the conjoined perfection of form and purpose the ancient Greeks celebrated.

4. I don't know why I made this patently false statement about hair styling. Perhaps because I wear an extreme crop, what Roland Barthes once called the "zero-degree haircut." See Roland Barthes, *Writing Degree Zero*, trans. Annette Lavers and Colin Smith, (New York: Hill and Wang, 1977)

5. Genuine not in the sense of "authentic," just definable and up for discussion. Nostalgia for style constitutes a style, if not a very healthy or original one.

6. Coupland meant, among others, the ubiquitous Ford Taurus, with its prominent rearward bulge. Is this some kind of primate sexuality in play among automotive designers?

7. This toilet never failed to remind me of the one David Foster Wallace became obsessed with in his account of a week spent on a Caribbean cruise ship. See "A Supposedly Fun Thing I'll Never Do Again," in his collection of the same title (New York: Little, Brown, 1997).

8. See Walter Benjamin, "The Work of Art in the Age of Mechanical Reproduction" (1934) in *Illuminations*, trans. Harry Zohn, (New York: Schocken Books, 1969).

9. Compare Adorno and Horkheimer, "The Culture Industry" (1945), Simon During, ed., *The Culural Industries Reader* (London: Routledge, 1993), pp. 29–43: "Hence the style of the culture industry, which no longer has to test itself against any refractory material, is also the negation of style."

Walter Ostrom
Fish Vase with Mediterranean Pot, 1990
Earthenware, polychromeglaze, maiolica
35.5 x 31 x 7.5 cm

Robin Metcalfe's writing on art appears regularly in magazines such as *Canadian Art, Ontario Craft* and *ARTSatlantic* and *C Magazine*. A former independent curator, Metcalfe is curator of contemporary art, Museum London, and is the author of *Studio Rally: Art and Craft of Nova Scotia* (1999).

Writing Craft: An Interdiscursive Approach
Robin Metcalfe

Contemporary craft writing faces both economic and philosophical impediments: the difficulty of making a living writing about craft, and the unresolved relationship between crafts and visual arts discourses. Crafts discourse addresses material concerns of use, medium and making. My critical writing takes an interdiscursive approach. It shares with crafts discourse an engagement with the social use-context of objects and the social history of materials and productive processes. It shares with visual arts discourse an emphasis on the intellectual aspects of making objects. I will illustrate my approach by reading excerpts from three recent critical and curatorial texts.

The first is from an article called "Tempest in a Teapot: Walter Ostrom and the Clay Wars" published in *ARTSatlantic* (issue 56, Fall/ Winter 1996, pp. 4–5). It constitutes a review of the exhibition *Walter Ostrom: The Advocacy of Pottery*, which was held at the Art Gallery of Nova Scotia (11 May to 23 June 1996).

If Walter Ostrom is the advocate of pottery, do the ceramics of the Ostrom school constitute a pottery of advocacy? They manifest a clay practice that orients itself toward the pot, rather than to clay as a more generally sculptural medium, and thus towards craft and function, and away from the gallery as its primary site.

In the polarized context of contemporary clay discourse in Halifax, there is a strong pressure to declare one's allegiances, to confirm one set of prejudices and repudiate the other. I have worked in environments defined by both visual arts and by crafts discourse, and am aware of strengths and shortcomings of both. The discourse of crafts is well placed to address some of the central issues of postmodern conditions. It considers objects within the context of use and social relations. It challenges the regimes of value imposed on different media by virtue of their positions within class, gender and cultural relations. It maintains a direct engagement with the body, through its

continued respect for both traditions of handmaking (the body of the maker) and traditions of utility (the body of the user – a term that conveys a wealth of potential discourses beyond those implied by the viewer).

My second excerpt is from an article that I wrote for the summer 1996 issue of *Border Crossings* entitled "The Halifax Clay Wars" (issue 15:3, Summer 1996, pp. 66–68). It is a review of the exhibition *Clay: Medium-Based Practices* at the Dalhousie Art Gallery in Halifax (8 March to 28 April 1996).

Nova Scotia observed the International Year of the Pot as the Year of Earth and Fire. If that poetic designation avoided the contentious question of the vessel, ceramists in Halifax may nevertheless remember 1996 as the year of the clay wars: a year of ideological conflict in the contested terrain of ceramics.

That terrain has been dominated locally by the Ceramics Department of the Nova Scotia College of Art and Design (NSCAD), with Walter Ostrom as its Head. For twenty years, Ostrom has served as a pugnacious advocate of crafts interests, while producing brightly coloured maiolica earthenwares formed from local red Lantz clay. He and his students have established a recognizable NSCAD style of functional pottery in broad, playful gestures, often incorporating plant and animal forms in strong, contrasting colours.

Arthur Handy enters this narrative as the proverbial stranger who comes to town to clean up its critical discourse. Like Ostrom, he is a native of New York state who arrived in Canada in the 1960s and became the head of a ceramics department, in this case at the Ontario College of Art. Unlike Ostrom, Handy has shunned the "craft" category, identifying himself as a critical late modernist and pursuing a sculptural practice in clay and other materials.

The curator received his loudest applause at the opening for an observation he himself regarded as regrettable: namely that the visual arts section of the Canada Council had established separate juries for craft. Handy and the Ostrom camp agree on one thing: clay has been unfairly marginalized within critical discourse. Whereas Ostrom and company advance under the banner of craft, Handy, however, views the craft category as a ghetto: the major obstacle to clay being taken seriously. The title of *Clay: Medium-Based Practices*, announces Handy's ambition to free ceramics discourse in the region from the constraints of craft.

Several of Handy's own ideological opponents number among the eleven ceramists he selected for the exhibition, including Walter Ostrom himself. It quickly became clear that many of the artists in the show were at odds with the curator, and with one another, about Handy's curatorial project. The litmus test of one's allegiances was

one's attitude toward the height of the display plinths, which stayed close to the floor, in line with Handy's own sculptural conventions. None of the functional pottery was shown at table- or shelf-height, with the notable exception of Ostrom's; he was the one dissenter canny enough to negotiate the terms of display beforehand. His polychrome vessels, each titled *Flower, Vase and Brick* (1995), sat on a shelf and displayed cast-iron flowers by painter Gerald Ferguson.

It is always salutary for conventional wisdoms to be challenged, and Handy's selection, and his intelligent catalogue essay, inject valuable alternative perspectives into the prevailing discourse of Atlantic ceramics. There is a slightly musty feeling about this exhibition, however, a clinging to a certain repressive modernist reserve that casts a pall over some rather vibrant individual works. It seems to be Ostrom who has the last and most persuasive word. Each of his *Flower, Vase and Brick* pieces literally fuses two hand-turned, functional vessels to their support (a found brick of red Lantz clay). As he has so often done, Ostrom thumbs his nose at modernist prohibitions against obscuring, thickly coloured glazes, and plays peek-a-boo with the clay body, by dripping glaze from the brightly decorated vase elements onto their raw brick base, which is itself a functional counterweight to the heavy iron flowers. Wittily juggling contradictory elements, Ostrom demonstrates that you can have your plinth and eat it, too.

My final excerpt is from a presentation called "Teacup Readings: Contextualizing Craft in the Art Gallery" which was presented as part of a panel at the University Art Association of Canada Conference in Halifax in 1994.

The value of displaying craft in an art gallery is to allow ourselves a place of reflection and detachment in which to consider objects as craft. The difficulty is that a large part of the discourse of crafts is concerned with the object in use: with how the object discloses itself through use. Only through physical contact with the object, by which it is handled, grasped, worn, entered into, can the viewer fully appreciate how the object responds to the body: its taste, heft, and texture.

Craft discourse attends to the material ground, and by extension to the actions of the body in creating the object and in recreating it through use. Perhaps there is an inherent contradiction in displaying crafts in an art gallery. For the gallery is itself a kind of ground or support that we are expected to ignore. This separation from the ground has its roots in aristocratic, and later bourgeois, class culture, in its separation from productive labour. The object as craft is an occasion to re-engage our critical attention with the social and material context of creative production.

Ironically, however, it is art discourse, rather than craft, that today draws our attention to the gallery as institutional support, as

ideological ground of the object. That craft is pressing for admittance to the gallery on terms that are already discredited within the visual arts reflects the relatively impoverished and underdeveloped state of critical craft theory.

The art gallery is a historically determined site. It is not eternal or universal, and it is constantly changing. Perhaps we should consider the inventions of new kinds of display spaces for craft, ones analogous to the special pavillions that the Japanese construct for the tea ceremony, spaces where objects can disclose themselves within a context appropriate to the qualities we wish to consider. Such a project would require that we abandon the cult of the sacred object that must be preserved at all costs. As craft, objects are mortal – they live and die in use. To quarantine them in the use-less space of the art gallery can be to deny them the chance to be born."

When we talk about writing critically about craft we're usually talking about reviewing exhibitions, and the gallery is the context in which we view them. In order to have craft given the kind of serious attention that most of us wish it to receive, there has been a strategic move to place craft in a gallery. But placing it in a gallery has certain consequences which may not always be to the benefit of craft. To borrow a phrase from Janet Koplos, the gallery is a borrowed or appropriated context for craft.

Those of us who are editors of craft magazines or craft writers might consider focusing more on the object in use. I'm not arguing against writing about craft in the gallery, but we should consider supplementary types of writing about craft in other contexts and not, as a knee-jerk response, review craft only when it is on display in what is, in fact, a visual arts context.

In preparation for this panel we were asked to consider why there is not more craft writing and Janet Koplos has already touched on some of the reasons. It is important to reiterate that some factors are economic. There are two ways to make a living writing seriously about craft. One of them is to have a teaching career and the other is to write on contract as a freelance critic or curator, which is what I do. If you do that, then you are working in a field where most of your competition consists of academics who don't expect to make their living from publishing critical reviews. As a result, they are willing to do work for less than a living wage, and editors and publications and art galleries get used to employing people as critics and curators for less than a living wage. As long as that's the circumstance, there is not going to be as much writing as we'd like there to be about craft, and the writing we get will be written by academics. I don't wish to engage in academic bashing but there are certain consequences of writing in an academic context and it is very important that we have other kinds of writing represented. If we want them represented, we have to pay for them.

This also gives rise to what Janet Koplos has called "the niceness factor," a weakness of criticism, a culture of celebration rather than one of critical analysis. The other set of barriers impeding more and better craft writing are philosophical ones involving the unresolved relationship between craft and visual arts discourse. Now, people may groan and say that they are tired of talking about it but I think we need to look at why that discussion keeps coming back. After we groan, we always launch into a lengthy discussion. Blake Gopnik has called the separation an accident of history but I would argue with that. Most of the world we live in is the consequence of accidents of history. While the distinction between craft and visual arts may not be a necessary one – it certainly does not exist in many other cultures – it is nevertheless a strongly existing distinction, one we cannot will away by simply ignoring it. We are talking about histories that are centuries old. The relationship between these two discourses is frequently misunderstood as a problem of categorizing objects. In other words, is this object a craft object or a visual arts object? Often that is a nonsensical question. The same object, the same body of work, can be considered in either discourse and artists and craftspeople often make strategic choices about how to locate themselves; these may have less to do with the inherent character of the work than with where they are more likely to get serious attention and money. The reason why the debate keeps going on is that it is about something material and not simply a conceptual debate. It has to do with access to resources, to money, to grants, to funding and to the critical attention that enables money to flow to artists and craftspeople.

The art/craft debate usually comes up in the context of what is essentially a political initiative on the part of crafts community to get more serious critical attention. I've noticed that the crafts community often frames its claim for attention using the model of a repressed minority group. The results are familiar to me from my work as a gay activist, and so are some of the dangers, which have to do with essentialism and getting stuck within the parameters of identity politics. That is something I've spoken and written about in other contexts and won't go into further here. It often comes down to this question of trying to define what is craft instead of saying what are the consequences of viewing something as craft, knowing that we also have the option of viewing it as something else.

My last point has to do with identifying the characteristic elements of craft discourse as opposed to visual arts discourse. This is not meant to be an exhaustive or definitive description, but the three concerns that come to mind are material concerns of use, making and medium. By "use" I mean that the meaning of the work is complemented by or fulfilled and revealed in use. Now, much craft today is non-functional; however, even with non-functional craft the history and memory of use is often an important part of the cultural and experiential context in which we view it.

The issue of making has to do usually with making by hand, and this is probably the biggest ethical barrier between crafts discourse and visual arts discourse. Since the industrial revolution, there has been an inversion of values in the West having to do with handmade objects. Before the industrial revolution, objects were generally more highly valued in direct proportion to their refinement and their regularity. In other words, they were judged by the extent to which the maker's hand was erased, by the maker's skill in producing something that looked like it was made by the gods. However, it is the hallmark of industrial goods that they are regular and that there can be ten thousand absolutely identical versions of the same thing. Very few things are slicker than a Coke can, and so we have the invention of craft as we now know it, as Bruce Metcalf outlined in his talk yesterday.

With this inversion of value, the mark of the maker's hand became the thing we valued the piece for. In Japanese culture, that aesthetic existed for a long time before industrialization, but in the West, our valuing the roughness that is a sign of a thing's having been made by a human being is a by-product of industrialization.

Within the visual arts, this has been a much more complicated relationship. At times, the mark of the maker's hand has been the source of value in visual arts. You can see a conjunction in the work of Peter Voulkos and its relationship to abstract expressionism, as has already been spoken of this weekend. However, in the last thirty years, with the rise of postmodernism, there has been, within visual arts, a very strong move toward de-emphasizing the expressive mark of the maker. Many works are produced by industrial or mechanical means, which brings visual arts closer often to the condition of design. I'm glad that Mark Kingwell has spoken about design on this panel because we can enrich the discussion between crafts and visual arts discourses by remembering there is a third discourse that belongs there. There is really a triad: crafts, visual art and design. There are areas of overlap between all of them and the boundaries are in flux.

The third concern I associate with craft, that of medium, is in some ways the most slippery and contested. It is also the most heavily defended boundary between craft and art because it is the most vulnerable. A focus on the history of a given medium, its technical and social properties, is not unique to crafts. The classic modernism of Clement Greenberg, for example, emphasized the specific material qualities of painting as a medium rather than its narrative or pictorial content. However, there remains a traditional heirarchy of media based on class, gender and geocultural differences as well as technical properties. Thus oil painting on canvas, carving in marble and casting in bronze are understood as visual arts media, and valued accordingly, while tapestry, embroidery and clay are understood as craft media.

In recent years socialism, postcolonialism, feminism and gay liberation have all challenged the presumed intellectual heirarchy of utterances in different media. Within contemporary visual arts, all media are now understood to be theoretically permissible for visual artists to work in. A contemporary

artist can produce objects in clay or wool, but it is only for the traditional visual arts media that the specific expressive history of the medium is understood as a part of art history. An artist working in clay, for example, who engages the specific history of clay, particularly the history of the vessel, does so at some peril. This is a boundary I'm interested in rupturing. One of the reasons this boundary is so strongly defended, I think, is that painters fear demotion to the status of "mere" craftspeople.

An interesting case study of the consequences of visual arts ignoring the history of media we now classify as craft involves the Renaissance painter and sculptor Antonio del Pollaiuolo. He merits a mention in one of the standard texts, H. W. Janson's *History of Art*, for his engraving, *The Battle of the Ten Naked Men* (c. 1465–70), which served as an anatomical reference tool for visual artists wishing to represent the body in action. Janson puzzles over the enigmatic subject matter of the engraving and some of its unusual formal qualities. What he does not bother to mention is that Pollaiuolo also produced designs for ecclesiastical embroideries such as the great illustrated copes worn in Rennaissance cathedrals. I only know this from having done research into embroidery. When I went back and looked again at *The Battle of the Ten Naked Men*, it struck me that the heavily outlined and flattened elements of the composition resemble tapestry and embroidery patterns. In this case, one could argue that embroidery – which at the time enjoyed a high cultural status – influenced the development of painting through Pollaiuolo's engraving. You won't find that out from reading Janson.

My own approach, as I have said, is one that I would call interdiscursive. My craft writing is informed by visual arts, my visual arts writing is informed by craft. I share with crafts discourse a strong interest in the social-use context of objects and an engagement with the social history of productive material and process. I'm interested in writing about the social meaning of objects rather than their plastic or expressive qualities considered in isolation. Like Blake Gopnik, I share with visual arts discourse a strong interest in the intellectual making of the object in addition to the manual making of it.

I would disagree somewhat with Blake, however, about the value of specialized knowledge. There is value in all kinds of approaches and people writing from different areas, but one of the problems with crafts writing in a visual arts context is precisely the access (or lack thereof) that the writer has to specialized knowledge. I agree that the reader doesn't need specialized knowledge, but often the responsibility of the writer is to impart supplementary information necessary for a richer reading of the work. To continue with the example of maiolica, I remember having a very interesting discussion with a visual arts writer who'd written a review of the Arthur Handy clay show, who came to it with a visual arts attitude that he really didn't need to know a lot about the medium because he could deal with the object as he encountered it in the gallery. When I talked to him about the history of maiolica, however, his position shifted. Maiolica was traditionally a low-status medium – it was poor people's porcelain, able to reproduce some of the

Article continues on page 122

Léopold L. Foulem
Blue and White Jam Jars with
Mickey and Minnie, 1993–1995
Ceramic and found objects
18.5 x 27 x 13 cm

Writing about Craft: Questions and Answers

The following includes highlights of a very lively question and answer session moderated by Sarah Quinton. Three of the panelists were Blake Gopnik, Mark Kingwell and Robin Metcalfe.

Q. You suggested that there might be ways to write about the object in use. How can we do that? I think even architecture criticism often doesn't deal with the building in use; it deals with it as a kind of ideal form and not as it is experienced.

R.M. I've been thinking about that over the last couple of days and I don't have any real answers, only suggestions that have occurred to me and each of them raises its own problems, but the interesting thing would be how we solve those problems. If we look back to William Morris, for example – at the beginning of the mid-nineteenth century [from whence we derive] some of our contemporary ideas about craft – the context then was in a domestic dwelling, with other objects in a domestic space. So, one possibility would be to go into domestic spaces and write about the object as it occurs in the life of the person who uses that object. Obviously that requires co-operation with the person in that space. It raises new ethical questions about criticism because it's not a public space as is a gallery. You are not there by right as a member of the public. We can also look at the world of design where there are public spaces that have craft objects in them such as furniture and we can look at how they occur in that space. Design criticism has already to some extent had to deal with that question. We have to see whether we can put ourselves in those spaces and write in a critical mode about how those objects function there. Another approach is to take individual objects and to engage with them. If we are dealing with functional work, for example, why not engage with the work in a functional way, why not have tea with the teapot and the tea cups and write on the basis of that experience and not simply on a visual experience?

Q. Have you actually done that? Have you found writing outlets that will allow you to write in that way about those things?

R.M. I can't say that that's something I've undertaken; it's in preparing for this panel that I've thought I should actually try to do that.

B.G. What happens is that you can be frustrated by some contemporary crafts that don't give the opportunity for speaking in terms of functionality, and I think the issue of function versus a more fine arts attitude can be a frustration for writers. Sometimes you wish that there were more contemporary crafts on the cutting edge, crafts that actually could invite that kind of discourse. A lot of them, like Léopold Foulem's work, which I admire a great deal, deliberately prevent that kind of discourse, and not always necessarily; sometimes it's just a gesture of seriousness to make an object that could be functional deliberately non-functional.

M.K. I would like to make two apologies: One is for being an academic and for driving down the prices for freelance writers in this country, but secondly for being a philosopher and having been complicit in the continuing influence of Kant's critique of judgment, which I have to say I keep coming back to again and again as these questions get played out. This question of utility versus other values is something I'm not sure we can settle here – in fact I doubt it. But, clearly this notion that disinterest is the mark of art and every-thing else falls into some other, often, if not always, subsidiary category, has a link with Kant's critique of judgment. That defence of art spreads its influ-ence throughout the West from that point in the late eighteenth century onwards. Interestingly, if you go back to premodern thinking about art, even in the West, you actually find a union of utility and beauty being defended by early modern and certainly ancient thinkers about the arts, including painting and sculpture. This is tangled up in historical and sociological issues about the creation of the modern gallery and the museum and so on. I agree, Robin, that the recognition of the historical status of those questions doesn't simply (by virtue of being recognized) solve the problem. What it does give us is the ability to start seeing those structures as contingent rather than necessary and then we can go after them, in discourse and in other ways.

B.G. It's worth pointing out that there are necessary disjunctions and struc-tures as well, but it's not that all distinctions are historical (that there are sensi-ble distinctions and less sensible distinctions), distinctions come from the way the human mind is made among other things. The distinction between art and craft is a particularly contingent distinction.

R.M. It's also important to remember that it's contingent on a number of factors like class and gender, geocultural differences, et cetera ... and one of the very tricky things around this question of what you know about medium

is that materiality is the most heavily defended boundary between craft and the visual arts, defended on the visual arts side, precisely because it's a little slippery and the most easily evaporated of the differences. All the hallmarks concerned with medium in craft are also present in traditional visual art media, such as oil painting, bronze casting, carving and marble. Much of the reason why those ["fine art"] media resist being considered in the same way, or resist jewellery or fibre or clay being considered in the same way, is that they're afraid of being demoted to craft. In craft discourse especially, [it's been interesting to follow] the discourse around fibre, because feminist critical work over the last thirty years is challenging the intellectual hierarchy of different media. One of the consequences of where we are is that, as Janet noted, within contemporary visual arts all media are theoretically permissible, but only those media that have a history in the visual arts, like oil painting, bring all their history with them, as part of visual arts discourse. Someone working in the visual arts is expected to know the history of oil painting and bronze casting as media. They are not expected to know the history of clay or fibre, and in fact the people working in craft don't know that history – fibre workers don't know clay history and clay workers don't know the history of fibre. That is why there is not a better developed clay discourse. Those histories of different media have to be introduced into the broader discourse of cultural activities.

Q. [to Blake Gopnik] When you said you had to argue to get your editors to treat craft in the same manner as art ... you have to argue with them but do you frame your piece in that way? Essentially what you read us was telling us, "Hey, look at this stuff, I bet you never thought it could do this," so you were identifying jewellery interest as an exception or as a novelty. Does it have to be done that way, and isn't that interest in the newness of the thing, isn't that just playing up? It's a newspaper, so it wants to have news, so it's not dealing with connoisseurship or other ways of responding to the subtleties of an object rather than the news of its interest.

B.G. Yes and no. As I said, one of the messages I want my readers to go away with is actually that possibility of looking at jewellery as though it were visual art. So that was a very deliberate rhetorical structure.

Q. Couldn't you just write about what was interesting? Couldn't you just deal with it as though it were just as interesting as a painting?

B.G. There are lots of different goals you could have. Given the state of craft criticism, especially in popular media, it's more important to me to talk about that as a phenomenon rather than saying anything in particular about these works of jewellery, which I did. I didn't ignore that entirely, but I don't care if my viewers agree or disagree or remember any of the single things I said. What matters to me is that they will go home and say, "Hey, you know what,

you can take jewellery seriously!" So that's what the piece is really. It's not about the specifics here, it's about that phenomenon.

Q. If you were dealing with a solo show, could you talk about a selection of jewellery objects in the visual terms of painting or sculpture?

B.G. "Could" in what sense? [Do you mean] would I be allowed to? I'd fight for it but I'm lucky that I work for a paper that gives me a lot of leeway. Sure I could and I'd like to believe that my readers would be willing, too. Here's a good example: I wrote about the Japanese designer Kuramata and I couldn't get it into the arts section; it had to go into the design section. Those kind of distinctions always come up, even though it was written with exactly the same kind of vocabulary and in the same general way as I'd write about fine art.

Q. Say you wrote about an interior design show, a great big trade show ... and the question is how much contemporary craft was in that show, and, if not, why not?

B.G. Maybe it was good that there weren't any crafts in that [hypothetical] show for the simple reason that crafts, if they are going to distinguish themselves from design, should be really pushing the envelope, should be made in small quantities, should not be looking necessarily to be sold and therefore should be very, very expensive. How often do you see works of craft costing anything like what a work by a modest mid-career painter would go for? I think it's a good thing for a craft when it's very, very expensive, when it's the product of having thrown out a whole lot of other objects that weren't up to scratch, where the craftsperson is deliberately not courting the market, is really pushing things beyond what the market can bear. I think for many crafts-people trying to make a living is actually in the end unhealthy, in that they necessarily end up moderating their creativity because they want to be in shows like this popular design show.

Q. Is it possible to look at commerce as a means of distributing one's ideas?

R.M. In answer to that, I'd like to disagree with Blake, to the extent that I wouldn't want to say that craft should only be at this end of the spectrum. One of the reasons that craft *is* so interesting is the spectrum. For example, all the non-functional works like the Léopold Foulems are great to see in a gallery and reveal a lot of meaning there, but they reveal it because we have an experi-ence of teapots and so, when we see a teapot that's full of holes, we have a certain reaction to it. We are able to appreciate that meaning because we have a functional history as well. To say all crafts should be over here at the academic and intellectual end is to buy into that old class hierarchy of practices, that notion that gentlemen don't get involved in trade and that only gentlemen are ultimately smart enough to engage in ideas. It's interesting that a lot of visual

artists in the last thirty years have gone in the other direction. People like Keith Haring, for example, or Barbara Kruger, who've produced objects intervening in popular culture, mass-produced objects, or intervened in ways that allow their work to be read by mass audiences. Craftspeople can use that kind of engagement. There are dangers in every kind of engagement. There are dangers in commercial markets and there are dangers in what I would call the academic market. It is not a matter of keeping out of either of them, it's a matter of knowing what the dangers are and intervening in an intelligent way.

Q. Is there a relationship between the stratification of our our post-secondary educational institutions and the stratification of the art, craft and design fields?

M.K. Of course it's absolutely true that certain kinds of discourse are valour-ized in certain kinds of institutions. I would be willing to make an argument as to why the university as an institution gives us a valuable discourse, despite whatever pathologies attend that project, and there are many. What I want to say in response is different altogether and maybe this is one of the miscon-ceptions about the status that universities hold. They are not functionally reproducing themselves in terms of the students that are being processed by them any more, if they ever were. In other words there may be some kinds of self-congratulation amongst the academics within universities, but the students who are being acculturated within universities are not reproducing that self-congratulation. They are not becoming academic in that sense, they are not becoming scholars, for better or worse. In fact, what strikes me over and over again with respect to the question we've been discussing, is my students' absolute lack of interest in the circumstances of production of anything that they encounter in the world. However, their degree of interest and connoisseurship about the surfaces of those products is amazing, and they have taught me a great deal about seeing the differences between a FUBU shirt and a Nike shirt. And believe me, that's a crude distinction, there are far more subtle ones. At that level they have a discourse that is as subtle and as discriminating as anything you would hope to see. But this goes back to the larger point I was trying to make in the essay that I read. What is char-acteristic about our consumer culture (and this is why discussion of craft or design tends to slide into lifestyle features), what is typical of our experience is that the circumstances of production are uninteresting, because what we want are the tokens without any awareness of the types. In fact, the types have been erased as uninteresting – this is the triumph of the industrial model. So, as a first step we should be trying to get people who consume these products to attend to the circumstances of their production and to me that's a question that is aesthetic, moral, political, cultural, social and on and on. I would like to see more of that discourse both inside and outside the universities.

R.M. I wanted to respond to Ron Shuebrook's point because I think that it relates to the art [versus] craft debate as well, because the relationship

between universities and colleges and the effort to perhaps erase differences between them is similar to the kind of dynamic that goes on between visual art and craft and sometimes corresponds with a historic association of colleges with trades. Colleges are where you learn trades, whereas universities are where you become intellectually trained. There is a strong impulse in our society to eliminate distinction, because often those distinctions represent class privilege. We are right to reject class privileges and we are right to question the basis of the distinction, but that doesn't mean the best thing to do is to get rid of the distinctions, because a lot of babies get thrown out with a lot of bath water when that happens. For example, I don't think it's a good thing, the infection of universities by college models where we expect philosophy students to earn a living as freelance philosophers and if colleges don't succeed at that then why have philosophy departments? That's one of the problems we run into. I have already explained how simply entering into arts discourse isn't always necessarily to the benefit of craft, so we have to critically examine distinctions and why they're there and how they might be different, without automatically saying, "Well let's just get rid of them and make everything the same."

B.G. There's something I was thinking about when you were talking, Mark, which is that it sounds as though you are willing to have a hierarchy between superficial style and more important concerns like real discourse in modernism – its political goals, reality ... How about if we reject that? How about if I were to claim that your students making a distinction between FUBU and Nike are actually on to something that's not only sophisticated and interesting but that's more important to how the world of the visual actually works than to what academics have traditionally done in terms of analysis? What stuff looks like is very, very important, and in modernism, for instance, the visual reality of modernism as pure style is more important than the utopian rhetorics of modernism. The truth is that there is no such thing as modernism. There is no one set of rhetorics that can explain modernism. One thing that modernism clearly seems to be is a set of visual almost-clichés. And style, pure style is actually very important and we have too little interest in careful analysis of pure style, because it's a low-status activity. Talking about things that are closer to philosophy is higher status than talking about the mundane, the visual, the material.

M.K. The only response I can offer is that I don't think that would be bad in itself. It's the most important thing. I really do endorse the hierarchy that you suggest. I do think the political question is the most important question. If the analysis of the place of style can be put in the service of the political question, which is what I argue for, then the more nuance and subtlety the better. What disturbs me is the way that the political dimension of creation, of style itself, gets shoved aside by the other questions that exist in the visual realm.

B.G. The danger is losing touch with the reality of the simply visual, of the pleasure and visual interest that dominate a lot of the changes that we see in art making. If you reduced it to an epiphenomenon of politics ...

M.K. Elevated to, not "reduced to"!

I really don't think we're in any danger of losing our awareness of the visual world. We're bombarded every day by the visual. We've got great discrimination of the visual. We don't have good political theory.

B.G. You can tell he's a political philosopher and I'm an art critic!

Q. Were we to synthesize these three areas that keep coming up, craft, art and design – for the consumption of those products, what is the upshot of collapsing those three distinctions and consuming them that way?

R.M. I would agree with you on half of your proposal, which is that we view objects without labelling them craft or art. I would argue, however, for not abandoning different types of venues and different discourses. In other words, I would like us to continue having crafts magazines and visual arts magazines, but I would like to see the visual arts magazine writing about craft and design, and the craft magazines writing about visual art and design, and doing so in the context of their own discourses. I think inevitably that's going to lead to some kind of merging into a common discourse. But it's not fruitful to pretend that that merging has already happened. I value each of those discourses and they also address particular communities, but I'd like to see very imaginative and open use of those [specialized] publications to bring in material that may be surprising to their audiences.

B.G. Officially that collapsing has happened. The Department of the History of Art at Oxford University is in the process of being renamed "visual studies," and when that happens you know that those distinctions have officially collapsed. Now that's only officially. They've officially collapsed in my work too and yet I write infinitely more about so-called fine art than craft, so it's a matter of getting over those historical traditions more than anything.

Q. Is there a more ideal siting for craft that would then engender a more productive environment for critical response?

R.M. My short answer to the question "Is there an ideal setting for craft?" would be emphatically "No." I'm arguing for many sitings that allow for many readings to take place and I'm not arguing by any means against the galleries. We need to remember the possibility of other sitings, because some meanings don't get revealed in a gallery setting. It's skewed toward certain readings. A lot depends on the character of the work. Some craft works

comes across fine in the gallery, other crafts suffer from that siting and lose some of their potential for meaning. I'm very much in favour of developing alternatives. I have suggested examining work in a domestic setting, examining works in a setting of use, whether they're public or private settings, engaging with individual objects as opposed to exhibitions of objects as some other strategies. The list goes on and I don't have a recipe at hand for how to do that. It's more a question of let's start thinking about those possibilities and let's not limit ourselves to the art gallery.

Q. To what extent does the written text convey, or erase, the final meaning?

R.M. It depends on the writing. It is the fault of bad writing that it can tend to fix meaning, to limit it, to impose meaning that you would then have to struggle to get beyond, to get to the object. This is certainly a pitfall that one has to be aware of in critical writing. Good critical writing opens up possible meaning, it doesn't pretend to be saying, "This is the meaning folks, here it is, don't even bother with the object, we've got this great review."

There is something in your question that I have a problem with and that is the notion that there is an unmediated meaning out there, some natural and essential meaning that has to be preserved from the interference of the text. The meaning of the work is always already mediated, meaning that when we come to the object we are already coming as a cultured being. The whole attitude by which we enter the space in which the object exists is one that is determined by discourse, by language, by the way we've grown up as people in a culture. There are experiences that are non-verbal and need to be valued as such, and that's one part of the spectrum, but there is a danger of romanticizing that experience and seeing text as an invasion. What happens then is that you don't examine the way in which your experience is already constructed by discourse. What I am arguing for is critical awareness of how discourse shapes your understanding of things, partly in order to free you from discourse. Good critical writing should help to free you from the bonds of writing rather than to imprison your experience in it. It should open up experience rather than shut it down.

M.K. I would just like to add one thing to that. [Musician and artist] David Byrne once said that writing about art was like dancing about architecture, and I say, why not dance about architecture!

Q. Do we ever see the coming together of the two questions, namely how things are made and what they mean?

R.M. In good criticism they always come together. Any criticism that ignores what an object looks like and how it is made would be weak criticism. One of the things that leads toward that possibility is attention to how objects are

made socially, not just how they are made physically. A trend that links visual arts and crafts discourse right now is [paying] attention to how objects come into being in a social world and what they mean as a result of how they move through that world. I see that as a point of interaction between those two ways of looking. It's just starting to happen in some areas of art history.

globalized. As textured and knotty as the cultural fabric is, we are essentially now dealing with the same set of phenomena. No one doubts, albeit begrudgingly, that the visual arts have a collective symbolic and hierarchical dimension that makes them important. But it is surprisingly difficult, from the eclectic heights of the professional craft world, to say why it all looks as it does (why it looks oddly *cohesive*) and why we actually bother. This is partly because we are all profoundly institutionalized, and partly because we are living in a genuinely complicated period.

As I have said, the next phase of modernity will be to do with four phenomena. It will be interdisciplinary because the next phase of intellectual growth, which has been underway for several decades but is only just coming into full effectiveness, is premised on relational rather than reductive visions of life. Interdisciplinarity does not imply a lessening of the specialized intense knowledges that make the various visual arts what they are, but rather the recognition that their interaction, and additionally the development of new approaches premised on interaction, is the key to the next phase of modernity. It is all to do with a coming together of lateral and vertical modes of creativity. *Globality* is an obvious phenomenon in every aspect of life, from the food we eat to the cities we live in to the terrorists we fear. Recognizing globality is not the issue: coping with it so as to not lose individual cultures is the issue. *Pan-technicality* is going to transform craft practice most. The sciences and arts finally appear to be capable of ending the "two cultures" syndrome that has dogged and undermined industrialized culture for several centuries. At the level of training and research, the gap between the arts and sciences grew so wide during the twentieth century (the age of subject specialization) that scientists and artists understood each other principally through caricature. This situation has been steadily changing, as the literatures of the two worlds begin to reveal common threads and new technology and new art meet and meld on the streets of the world's industrial conurbations. We will soon be buying six-packs of computers at the local grocery store and every craft studio will be an effortless melange of traditional tools and high technology. I recently judged a competitive craft exhibition via email. This would have been a science fiction dream a few years ago, but it is a sign of things to come in all aspects of the craft world. Good thing too. An eclectic object is one that naturalizes into its fabric many disparate sources. Most art has been eclectic in one way or another for much of the modern Western tradition. *Eclecticism* is fundamental to the decorative arts. The last form of modernism to dominate design and architecture was antieclectic, and so it was antidecorative. The next phase of modernity will be eclectic, and so it will celebrate decoration. We have exciting times in front of us. We should look forward to them without trepidation. And for a while, it would be as well if we did not look behind us.

purpose-built pieces can. I am the investor in this case, intimately involved in the risk of loss – the loss of material, time and sometimes credibility. But I do it anyway, because it allows me to form a conjectural opinion on the place of my work in a broader continuity than would otherwise be possible were I to confine myself to producing pieces that went from studio to client's home with only a stop for gas in between.

I love the word "speculate." It is so rich with promise. I don't gamble; I'm too much of a naysaying Calvinist for that. Speculation is as close as I get, and sometimes that is way too close. I'll give as an example a piece I made for a solo exhibition ten years ago. I had been inspired by seeing the burial sarcophagus of an abbess in southern Holland. I drew and drew and then made quarter-scale models. When I felt that I had resolved the final concept, I made the piece and delivered it to the gallery. It didn't sell in the show, and so it came home with me. Standing five feet high and five feet wide, it took up a fair amount of space in the house. I gradually realized that although there were several reasons why I had made it, there were equally good reasons as to why it hadn't sold. I had been intrigued by how it looked as a scale model. One-fourth-size, as it turned out, was the right size, so early one Saturday morning I blew it apart with a car jack and burned most of the pieces. I saved the leg elements and years later made three small tables which I now realize formed a turning point in my work.

Continued from page 73 / Shuebrook

Notes

1. Higher education in Ontario is divided into two non-integrated sectors: universities, including the Ontario College of Art and Design, and the colleges of applied arts and technology. The college system is non-degree granting. This brief overview addresses the university system. Although influential colleges such as Sheridan College School of Crafts and Design teach craft history, the goal of this system is to educate practitioners rather than scholars.
2. Arthur C. Danto, *Encounters and Reflections: Art in the Historical Present,* (New York: Farrar Strauss Giroux, 1991), p. 323
3. Gunnar Swanson, "A Graphic Design Education as a Liberal Art: Design and Knowledge in the University and the 'Real World'" in Steven Heller, ed., *The Education of a Graphic Designer*, (New York: Allworth Press and the School of Visual Arts, 1998), p. 14
4. Swanson, ibid.
5. Swanson, ibid., p. 15

Acknowledgements

I must express my deepest gratitude to M.C. Richards for her inspired writings on craft, education and wholeness. *Centering*, her extraordinary book from the mid-1960s, has been an important influence on my own thinking about craft as evident in this paper. I also wish to thank Fran Merritt, founding Director, Haystack Mountain School of Crafts, for offering me the privilege of spending two miraculous periods of study at that remarkable school in the summers of 1965 and 1967.

Continued from page 77 / Griffin

steel is made from scrap material. Most of the steel pictured in Rivera's frescoes is currently in the form of your car, your washing machine, your refrigerator. What I am suggesting is that steel is a physical representation of memory, the memory of other forms, other jobs, other times.

"I have chosen to construct a garden within the Rivera Court. This former garden court becomes the site for a new garden of steel scrap. The centre of the beds, the mulch, is made from processed steel scrap, scrap that had been recycled and was ready to be shipped to one of the many steel refineries in the Detroit area. The frames for each of the beds are made from conveyor chain. Rivera chose the image of conveyor chain as an aesthetic device both to frame sections of his murals and to convey the idea of mechanical mobility. I am using actual conveyor chain to frame and define the garden and to suggest the active stewardship of the gardener. This garden is in effect our garden. It is the garden of twentieth-century mechanical civilization. For me it is both beautiful and tragic."

P.S. You may not be driving a piece of junk, but you are driving scrap!

Notes

1. "Remaking Material," an audio-visual lecture co-authored and presented by Gary S. Griffin and Erika Ajala Stefanutti. Society of North American Goldsmiths Annual Conference 1995, New Orleans, Louisiana (transcript available)

Bibliography

Also see Griffin, Gary S. and Stefanutti, Erika Ajala, "Remaking Material," *Metalsmith*, Summer 1994, pp. 32–39.

Continued from page 107 / Metcalfe

effects of porcelain but with lower-status clay bodies. Much of the richness of the meaning of the work comes through an awareness of that history. It can be very valuable for the critic to learn enough of that history to be able to appreciate these layers of meaning and to suggest them to the reader.

Photo Credits

Page 10, left to right
Minton, Ltd., Britain
Monkey Teapot, Maiolica ware, c.1880
Glazed earthenware, 15 cm
Private collection

Bicyclist
Courtesy: Ontario College of Art and Design

Rebecca Kelly
Jewellery Studio, c. 1991
Courtesy: Craft Studio, Harbourfront Centre

Page 40, left to right
Clarice Cliff, Britain
Teepee Teapot, c.1950
Glazed earthenware
15 cm
Sotheby's, London
This postwar piece, designed specifically for the
Canadian market, reads "Greetings from Canada"
on the base

Stephan Seyffert
Coral Necklace
Silicone
Courtesy: Charon Kransen

Potter Mary Philpott, c.1994
Courtesy: Craft Sudio, Harbourfront Centre

Page 78, left to right
Verena Sieber Fuchs
Neckpiece
Wire, candy wrappers
Courtesy: Charon Kransen

Susan Rankin
Flowering Vine Vessel, 1999
Hot blown glass

Potter Karen Franzen, c.1991
Photo: Sally Ayre
Courtesy: Craft Studio, Harbourfront Centre

Editor: Jean Johnson, C.M.
Cover/Book Design: Burton Kramer
Production: Elaine Thompson
Copy Editor: Betty Ann Jordan

Co-published by:

Coach House Books
401 Huron Street (rear)
Toronto, Ontario M5S 2G5
www.chbooks.com

Harbourfront Centre
235 Queens Quay West,
Toronto, Ontario M5J 2G8
⊙ Harbourfront centre